To:

..

From:

..

Date:

..

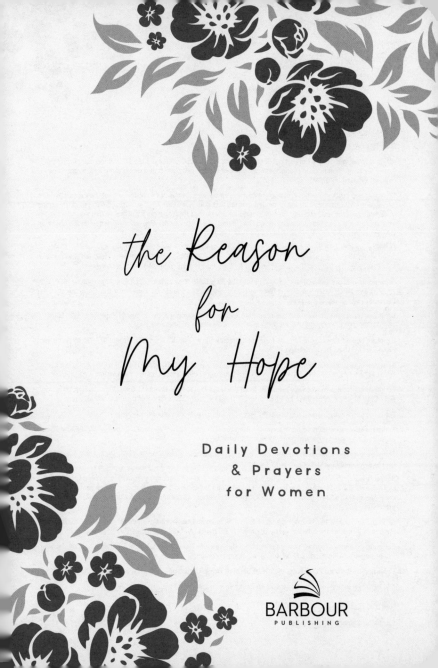

the Reason for My Hope

Daily Devotions & Prayers for Women

BARBOUR
PUBLISHING

Devotions and prayers from *Nevertheless, She Hoped* by Debora Coty and Laura Freudig; *Nevertheless, She Believed* by Laura Freudig and Vicki Kuyper; *Nevertheless, She Was Chosen* by Jessie Fioritto; and *Nevertheless, She Was Courageous* by MariLee Parrish. Published by Barbour Publishing, Inc. All rights reserved.

Our mission is to inspire the world with the life-changing message of the Bible.

Printed in China.

What's the Reason for YOUR Hope?

Your heart should be holy and set apart for the Lord God.
Always be ready to tell everyone who asks you why you
believe as you do. Be gentle as you speak and show respect.
1 PETER 3:15 NLV

Want to grow deeper in your faith? Do you desire an intimate connection to the heavenly Father's heart? Then this daily devotional collection is just for you! These practical and faith-filled devotions will help you celebrate God's beautiful gift of hope.

Read on. . .and discover a deeper understanding and love for the one who holds the whole world in His hands.

Be blessed!

Day 1

Walking Faith

*Be strong and courageous, and act; do not fear
nor be dismayed, for the LORD God, my God,
is with you. He will not fail you nor forsake you.*

1 CHRONICLES 28:20 NASB

What a life verse! What a creed to live by! We are assured that our God will never leave us or forsake us. We draw strength and courage from this assurance and are then able to *act*: to share our faith boldly—without fear—because we are never alone. The Lord God—*our* God—is with us.

*Lord, Your promises give life—they are life.
Thank You for promising never to fail or forsake us.
Thank You for being the source of our strength and
courage. Give us the faith to live without fear in the
light of Your promises. In Your precious name, amen.*

Day 2
Shouts of Joy

He will yet fill your mouth with laughter
and your lips with shouts of joy.
JOB 8:21 NIV

Do you remember the last time you laughed till you cried? For many of us, it's been far too long. Stress tends to steal our joy, leaving us humorless and oh-so-serious. But lightness and fun haven't disappeared forever. They may be buried beneath the snow of a long, wintry life season, but spring is coming, girls. Laughter will bloom again, and our hearts will soar as our lips shout with joy. Grasp that hope!

Dear Lord, help us look actively for moments of joy—not just the hollow, fleeting joys the world offers but the true, lasting, eternal joys that come only from You. Help us keep our eyes looking in the right direction: fixed on Jesus and the joy set before Him. Amen.

Day 3

I'm No Eeyore

*Then [Job's] wife said to him, "Do you still hold
firm your integrity? Curse God and die!"*
JOB 2:9 NASB

Job's wife was the unwilling recipient of Satan's attacks because of her husband's righteous life. When the going got tough, our girl lost faith and hope disintegrated. We too sometimes lose sight of all God has done for us and focus only on what He *didn't* do. Our attitudes nosedive, and negativity imprisons us. Job's response is the key to escaping the shackles of Eeyore-ism: "I *know* that my Redeemer lives" (Job 19:25 NASB, emphasis added).

*Father, when life gets hard, help us to cling even
tighter to You. There is no other rock, no other
redeemer, no other strong tower, no other provider,
no other sustainer, no other savior. You are all that
and more. In thanksgiving and faith, amen.*

Day 4

Be Strong

Finally, be strong in the Lord and in his mighty power.
EPHESIANS 6:10 NIV

Be strong. Toughen up. You've got this. Put on your big-girl pants. You've heard all these (ahem) encouragements before, right? But do they ever help? Not so much. These types of "encouragements" are just urging you to dig down deep and find strength in yourself. But what happens when you're just plain out of strength?

The Amplified Bible says it this way: "Be strong in the Lord [draw your strength from Him and be empowered through your union with Him] and in the power of His [boundless] might."

Jesus encourages us to come to Him over and over. He's the living well that will never run dry. We can draw our strength from Him when ours has run out.

Jesus, You are the mighty one. I'm so thankful
I can come to You for strength.

Day 5

From God's Perspective

*Has not God chosen those who are poor in the
eyes of the world to be rich in faith and to inherit
the kingdom he promised those who love him?*
JAMES 2:5 NIV

Being rich in faith is the secret to leading an abundant life. That's because faith allows us to see life from God's perspective. We begin to appreciate how much we have instead of focusing on what we think we lack. We understand that what's of eternal worth is more valuable than our net worth. We feel rich, regardless of how much, or how little, we own. True abundance flows from the inside out—from God's hand straight to our hearts.

*Dear Father, we are blessed beyond measure—both
now and in eternity—because You have given us the
immeasurable gift of Your only Son, Jesus Christ. Help
us to keep our eyes fixed on that treasure, which will
never fade and cannot be taken from us. Amen.*

Day 6
Holy Spirit Power

Do not fear [anything], for I am with you; do not
be afraid, for I am your God. I will strengthen you,
be assured I will help you; I will certainly take
hold of you with My righteous right hand [a hand
of justice, of power, of victory, of salvation].
ISAIAH 41:10 AMP

If you've accepted Jesus Christ as your Savior, the power of the Holy Spirit resides within you. Either we believe this as Christians—or what is the point? In John 16:7 (ESV) Jesus says, "I tell you the truth: it is to your advantage that I go away, for if I do not go away, the Helper will not come to you. But if I go, I will send him to you."

Jesus, thank You for sending Your Spirit to live
inside me to teach me and give me strength.

Day 7

No Comparison Necessary

*We will not compare ourselves with each other
as if one of us were better and another worse.
We have far more interesting things to do with
our lives. Each of us is an original.*
GALATIANS 5:26 MSG

When God created each of us, He wove together a wonderful woman unlike any other. But at times it's tempting to gauge how well we're doing by using other women as a measuring stick. Faith offers a different standard. The Bible encourages us to use our abilities in ways that honor God. Some abilities may take center stage, while others work quietly in the background. Just do what you can with what you have in ways that make God smile. No comparison necessary.

God, when I see another woman with gifts that I wish I had, help me turn my envy into praise. Thank You for her. Thank You for making her a light and inspiration to many. Help me support her in the work You've given her so that You may be glorified even more. Amen.

Day 8
Be on Guard

Be on guard. Stand firm in the faith.
Be courageous. Be strong.
1 CORINTHIANS 16:13 NLT

Let these lyrics of the old hymn "God Will Take Care of You" by Civilla D. Martin strengthen and encourage your spirit:

> *Be not dismayed whate'er betide,*
> *God will take care of you;*
> *Beneath His wings of love abide,*
> *God will take care of you.*

Song of Solomon 2:15 mentions "little foxes" that come in and steal our joy and our confidence in Christ. Be on guard for that. When your heart feels heavy, take courage in the God who always helps. And then let your heart be lifted by the words of Psalm 23:6 (NIV): "Surely your goodness and love will follow me all the days of my life."

Jesus, I trust You to guard my heart. You are so good to me.

Day 9
Inside-Out Love

God has made everything beautiful for its own time.
ECCLESIASTES 3:11 NLT

Beauty is a concern of every woman to some degree. We worry bout hair, makeup, weight, fashions. But real beauty can only come from God's inside-out love. Once we are able to finally comprehend His infinite and extravagant love for us—despite our flat feet and split ends—our heart glow will reflect radiant beauty from the inside out. Only when we feel truly loved are we free to be truly lovely.

Dear Lord, our hearts are often beyond our own comprehension. But they are not beyond Yours, for You made us. Open our ears to the lies we are believing when we think we are not beautiful; open our eyes to the false images we are worshipping. In Jesus' name, amen.

Day 10

Strength from His Spirit

For God did not give us a spirit of timidity or cowardice or fear, but [He has given us a spirit] of power and of love and of sound judgment and personal discipline [abilities that result in a calm, well-balanced mind and self-control].

2 TIMOTHY 1:7 AMP

The Passion Translation says it this way: "For God will never give you the spirit of fear, but the Holy Spirit who gives you mighty power, love, and self-control."

If you are experiencing overwhelming fear or a sense of defeat and discouragement, you can be assured that it didn't come from God. "Perfect love casts out fear" (1 John 4:18 ESV). The Spirit that is alive in us is full of power, love, sound mind, and abilities that are beyond our own power and understanding.

Jesus, I need strength from Your Spirit.
In Your powerful name, I cast out all fear and
discouragement that come against me.

Day 11

Exceeded Expectations

*I have come that they may have life, and that
they may have it more abundantly.*

JOHN 10:10 NKJV

In Jesus' day, the people of Israel were looking for the Messiah promised in scripture. They believed this Savior would restore Israel to its former power and prosperity. Jesus didn't meet their expectations—He exceeded them. Jesus offered them an abundance of riches that couldn't be stolen or decrease in value—true treasures like joy, peace, forgiveness, and eternal life. Jesus offers these same treasures to you. All you need do is place your faith in Him.

> *We want what You want, Lord. We want to desire
> the things You desire. Forgive us for being goaded
> and deceived by the world into wanting the things
> that it offers. We ask for the Holy Spirit to fill us so
> we will desire everything that pleases You. Amen.*

Day 12

His Strength and Presence Continually

Seek the LORD and his strength;
seek his presence continually!
1 CHRONICLES 16:11 ESV

God created female brains with the amazing ability to multitask. We can feed a baby, plan a grocery list, help with homework, and sign mortgage documents all at the same time without missing a beat! We also have the ability to do multiple tasks and be present with God at the same time. How are you doing at seeking the Lord during your day? Are you asking Him for courage and strength to complete your tasks? Take some time to pray, and ask God to give you a reminder that He is with you. Being a woman can be exhausting, but it doesn't have to be. Remember to rest in the strength and presence of Jesus.

Jesus, I want to seek You more than I do.
Remind me that You are with me always.

Day 13
Everyday Blessings

But the eyes of the LORD are on those who fear him,
on those whose hope is in his unfailing love.
PSALM 33:18 NIV

The Lord of all creation is watching our every moment and wants to fill us with His joy. He often interrupts our lives with His blessings: butterflies dancing in sunbeams, dew-touched spiderwebs, cotton-candy clouds, and glorious crimson sunsets. The beauty of His creation reassures us of His unfailing love and fills us with hope. But it is up to us to take the time to notice.

Dear Father, it's almost as though You are saying in those
small moments, "Here I am. This is all for You. Look at
how much I love You." Help us to hear Your voice and
notice Your gifts and pour back praises to You. Amen.

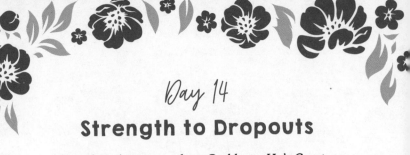

Day 14

Strength to Dropouts

GOD doesn't come and go. God lasts. He's Creator of all you can see or imagine. He doesn't get tired out, doesn't pause to catch his breath. And he knows everything, inside and out. He energizes those who get tired, gives fresh strength to dropouts.
ISAIAH 40:28–29 MSG

Have you ever felt like a dropout of the faith? Don't beat yourself up for being human. Jesus wants you to come to Him exactly as you are and work things out with Him. God wants your heart, not your perfect behavior. If you messed up today, or even if you mess up every day, bring your messes to Jesus. There's no need to hide them, because He already knows. Ask Him to search your heart. Give Him permission to help you sort everything out.

Lord, I know that nothing I could ever do will make me more deserving of Your love and grace. You pour them over me because of Christ alone. Thank You for giving me strength.

Day 15

Firm and Immovable

*As for the promise which I made with you when
you came out of Egypt, My Spirit stands [firm and
immovable] and continues with you; do not fear!*
HAGGAI 2:5 AMP

The Message paraphrase says this: " 'Yes, get to work! For I am with you.' The GOD-of-the-Angel-Armies is speaking! 'Put into action the word I covenanted with you when you left Egypt. I'm living and breathing among you right now. Don't be timid. Don't hold back.' "

The God of angel armies is your God too. He is with you and for you. He is living and breathing in you. He is firm and immovable, standing with you—always. He will never ask you to go somewhere or do something that will cause Him to leave your side.

*Lord, You are the great God of angel armies.
And yet You are alive and at work inside me. That's
so amazing! Thank You for never leaving my side
and for bringing me courage from Your strength.*

Day 16
Completely!

*The Spirit makes us sure God will
accept us because of our faith in Christ.*
GALATIANS 5:5 CEV

God accepts you completely. You don't need to clean up your language, change your lifestyle, or step inside a church. Once you put your faith in Jesus, things between you and God are made right. Period. But acceptance is only the first step in this relationship. As God's Spirit continues working in your heart, He gives you the desire and strength you need to mature into who you were created to be—an amazing woman whose character reflects God's.

*Dear Lord, we praise You that because of the perfect
sacrifice of Jesus, we are acceptable to You in any
condition: even when we're broken, weary, filthy,
crooked. We praise You that You don't discard
us or dismiss us as worthless. Instead, You make
us new. In praise and thanksgiving, amen.*

Day 17

My Refuge

God is our refuge and strength,
always ready to help in times of trouble.
Psalm 46:1 nlt

What is your quiet place? The place you go to get away from the fray, to chill out, think, regroup, and gain perspective? Mine is a hammock nestled beneath a canopy of oaks in my backyard. . . nobody around but birds, squirrels, an occasional wasp, God, and me. There I can pour out my heart to my Lord, *hear* His comforting voice, and *feel* His strength refresh me. We all need a quiet place. God, our refuge, will meet us there.

> *Dear Lord, I thank You for allowing me to have*
> *a peaceful place to draw near to You. I realize*
> *what a gift that is and how many people around*
> *the world have no such safe haven. Thank You*
> *for being so good to me in this way. Amen.*

Day 18

Coming Alive in Christ

*Death initially came by a man, and resurrection
from death came by a man. Everybody dies in
Adam; everybody comes alive in Christ.*
1 CORINTHIANS 15:21–22 MSG

Our own strength can sometimes look and feel like death. What does that even mean? Well, have you ever used your own strength to make someone else feel small? Going toe-to-toe in anger with someone else is often a power struggle due to pride and sin. Confess those times to Jesus. Ask Him to humble your heart and fill you with His strength instead. Francis de Sales said, "Nothing is so strong as gentleness. Nothing so gentle as real strength." As we come alive in Christ, He fills us with the fruit of His Spirit. One of those is gentleness. Ask for it in greater measure.

*Jesus, I confess my pride to You.
Wash me in Your gentle strength instead.*

Day 19
Celebrate!

*We remember before our God and Father your work
produced by faith, your labor prompted by love, and your
endurance inspired by hope in our Lord Jesus Christ.*

1 THESSALONIANS 1:3 NIV

When you work hard toward completing a goal, accomplishing
what you've set out to do is something worth celebrating. When
your accomplishment is fueled by faith, you can be certain you'll
never celebrate alone. God sees the time, energy, and heart you
put into your work. Better yet, He adds His own power to your
efforts. This means that with God, you can accomplish things
you could never do solely on your own. That's something truly
worth celebrating—with God!

> *Lord, thank You for blessing the work of my hands.
> Thank You for the plans You have for my future. . .
> plans to prosper me and not to harm me. I know I
> can trust You to carry them to completion. I look
> forward—with joy!—to what You will do! Amen.*

Day 20

A Little Goes a Long Way

*The LORD our God has allowed a
few of us to survive as a remnant.*
EZRA 9:8 NLT

Remnants. Useless by most standards, aren't they? But God is in the business of using tiny slivers of what's left to do mighty things. Nehemiah rebuilt the fallen walls of Jerusalem with the remnant of Israel described in the passage above; Noah's three sons repopulated the earth after the flood; four slave boys—Daniel, Shadrach, Meshach, and Abednego—kept faith alive for an entire nation. When it feels as if bits and pieces are all that have survived of your hope, remember how *much* God can accomplish with remnants!

*Dear God, we are believers now because people in
the past held on to their faith despite opposition and
hardship. Thank You for the remnants. Thank You
for showing Your power by working through the few,
not the many. We trust You for the increase. Amen.*

Day 21

Weak in Self, Strong in Christ

But he said to me, "My grace is sufficient for you, for my power is made perfect in weakness." Therefore I will boast all the more gladly of my weaknesses, so that the power of Christ may rest upon me. For the sake of Christ, then, I am content with weaknesses, insults, hardships, persecutions, and calamities. For when I am weak, then I am strong.

2 Corinthians 12:9–10 ESV

The apostle Paul had some sort of physical affliction (see 2 Corinthians 12:7–8). He begged God several times to take it away, but God said no. Why would He do that? Paul says that God did that for a reason: to keep Him reliant on God's power instead of being conceited and proud. God promises to be with us in our limitations. How are you allowing God to shine in your areas of weakness?

Jesus, help me to be content in my weakness,
allowing Your strength to shine through.

Day 22

Courageous Footsteps

Blessed is she who has believed that the
Lord would fulfill his promises to her!
LUKE 1:45 NIV

In Jesus' day, women had fewer opportunities to stretch their wings creatively and professionally than they do today. That didn't stop them from holding tightly to God's promises and stepping out to act on what they believed. You can follow in their courageous footsteps. Whatever you believe God wants you to do, big or small, don't hold back. Today, take at least one step toward your goal. With God's help, you'll accomplish everything He's set out for you to do.

Dear Lord, sometimes I'm afraid to keep walking
toward the goals You have planted in my heart. The
way seems long and hard. . .and I am still so far from
where I long to be. Yet I know that You are with me.
Help me take a step forward in faith today. Amen.

Day 23

It'll Be All Right

Our comfort is abundant through Christ.
2 CORINTHIANS 1:5 NASB

As children, there's no greater comfort than running to Mommy or Daddy and hearing, "It'll be all right." As adults, when we're frightened, dismayed, or dispirited, we yearn to run to enveloping arms for the same comfort. Abba Father—Papa God—is waiting with open arms to offer us loving comfort in our times of need. If we listen closely, we'll hear His still, small voice speak to our hearts: "It'll be all right, my child."

Lord, You are the Father of compassion and the God of all comfort. Help us to feel—even as we long for actual arms—that Your everlasting arms are already holding us. Forgive us for doubting Your love, and help us cling more joyfully and more desperately to You. Amen.

Day 24

My Strength and Song

*See, God has come to save me. I will trust in him
and not be afraid. The LORD GOD is my strength
and my song; he has given me victory.*

ISAIAH 12:2 NLT

Praising and worshipping God in hard times is incredibly powerful. Praising God in times of trouble requires a leap of faith. Psalm 32:7 (NIV) says, "You are my hiding place; you will protect me from trouble and surround me with songs of deliverance." The next time you feel like running away from your problems, hide out in Jesus instead. Crank up the praise music, and thank Him for His songs of deliverance. Watch and see how He makes a way for you!

*Jesus, I trust that You see me and know my heart.
I worship You during this hard time, knowing that
You've got my back and will move me forward.*

Day 25

Overflowing with Hope

We live by faith, not by sight.
2 CORINTHIANS 5:7 NIV

Faith changes how we see the world. From all appearances, your circumstances may seem daunting. Your opportunities limited. Your future set in stone. But when you place your faith in God instead of what you see, your heart can't help but overflow with hope. God's power is at work behind the scenes. He's working in both you and your circumstances. He promises to bring something good out of every situation, no matter how things may look on the outside.

> *Father, I am so grateful that I don't have to judge based on appearances—You look past appearances and so can I. No matter how dark the way seems or how weak and weary I feel, I know that You are—right now— working all things for good. With praise, amen.*

Day 26
Increasing Visibility

Where then is my hope?
JOB 17:15 NIV

On hectic days when fatigue takes its toll, when we feel like cornless husks, hope disappears. When hurting people hurt people and we're in the line of fire, hope vanishes. When ideas fizzle, efforts fail; when we throw the spaghetti against the wall and nothing sticks, hope seems lost. But we must remember it's only temporary. The mountaintop isn't gone just because it's obscured by fog. Visibility will improve tomorrow, and hope will rise.

> *Lord, help us pick the spaghetti up off the floor, rinse it well, and serve it with a smile! You are with us in these messy, sad, uncomfortable days when we can't see a step further than where we are right now. Help us fix our eyes on the unseen and eternal—on You. Amen.*

Day 27
Strength with People

The LORD is my light and my
salvation—whom shall I fear?
The LORD is the stronghold of my
life—of whom shall I be afraid?
PSALM 27:1 NIV

Knowing who you are in Christ gives you supernatural strength
and courage in any and every situation. If you have trouble with
other people's thoughts or opinions of you or consider yourself
a shy person who fears standing up for herself or others, then
this is great news for you! Get into God's Word, and discover
the truth about who you are in Christ. Ask the Holy Spirit to
teach you and remind you of what God's Word, says about you.
You are a royal daughter of the King of all kings. You can hold
your head high because you are God's child.

Lord, when I feel less-than around certain
people, remind me that I am Yours. Give me
the courage to speak up as You lead me.

Day 28
Spiritual Arsenal

*Put on all the armor that God gives, so you
can defend yourself against the devil's tricks.*
EPHESIANS 6:11 CEV

A woman donning armor brings to mind images of Xena the
Warrior Princess or Joan of Arc. But the armor God offers is
neither fantasy nor outdated. It's a spiritual arsenal of offen-
sive and defensive gear. It's comprised of weapons such as
truth, righteousness, peace, and faith. There's a battle going
on every day for your mind and heart. But there's no reason
to be afraid. Through faith, God's given you everything you
need to be victorious.

*Lord, thank You for the reminder that my only
offensive weapon is Your Word. Forgive me for treating
it lightly, for pushing it aside in favor of more urgent
(to my mind) things. Nothing is more urgent than
preparing for the battle You tell me I am already
in. Help me take up my "sword" daily. Amen.*

Day 29

Drawn Toward Jesus

In your relationships with one another, have the same mindset as Christ Jesus: Who, being in very nature God, did not consider equality with God something to be used to his own advantage.
PHILIPPIANS 2:5–6 NIV

Even those who don't believe Jesus is God can agree that He was an extraordinary person. The way Jesus selflessly loved others, reaching out to people whom society had cast aside—including women—demonstrates an attitude of compassion, humility, and service. We're drawn to those who sincerely care for us. That's one reason why we're drawn toward Jesus. Believing in a God who believes in us doesn't feel risky; it feels like accepting a free invitation to be unconditionally loved.

Dear Lord, thank You for loving us so much that You would send Your only Son to die for our sins. Help us to be more like You to the people around us. Help us to love, to welcome, to serve. Help us to offer both truth and grace in Your precious name. Amen.

Day 30

Lord of the Dance

Remember your promise to me; it is my only hope.
PSALM 119:49 NLT

The Bible contains many promises from God: He will protect us (Proverbs 1:33), comfort us (2 Corinthians 1:5), help in our times of trouble (Psalm 46:1), and encourage us (Isaiah 40:29). The word *encourage* comes from the root phrase "to inspire courage." Like an earthly father encouraging his daughter from backstage as her steps falter during her dance recital, our Papa God wants to inspire courage in us, if we only look to Him.

*Dear Father, our steps will falter. We will stumble,
and our faith will fail. That's just who we are
as imperfect children. Thank You for promising
never to leave or forsake us. Thank You for
always being there, whispering encouragement
and hope in our ears. We need You so. Amen.*

Day 31

God's People

The LORD gives strength to his people;
the LORD blesses his people with peace.
PSALM 29:11 NIV

When you become a child of God, you are instantly granted heavenly privileges. Look them up, write them down, start believing them today:

- I am free and clean in the blood of Christ (Galatians 5:1; 1 John 1:7).
- He has rescued me from darkness and has brought me into His kingdom (Colossians 1:13).
- I have direct access to God (Ephesians 2:18).
- I am a precious child of the Father (Isaiah 43:6–7; John 1:12; Galatians 3:26).
- I am a friend of Christ (John 15:15).
- Nothing can separate me from God's love (Romans 8:38–39).
- God is for me, not against me (Romans 8:31).
- God delights in me (Psalm 149:4).
- I am God's temple (1 Corinthians 3:16).
- I am chosen by God (Colossians 3:12).

Thank You, Father!

Day 32

Faith That Won't Fail

*If Christ wasn't raised to life, our message
is worthless, and so is your faith.*
1 CORINTHIANS 15:14 CEV

Faith, in and of itself, is nothing more than trust. If you place your trust in something that isn't trustworthy, your faith is futile. You can have faith that money grows on trees, but ultimately that faith isn't going to help you pay your bills. Putting your faith in Jesus is different. Historical and biblical eyewitness accounts back up Jesus' claims. That means putting your faith in Jesus is both logical and powerful. It's a faith that won't fail.

*Lord, we thank You for being the God who both walked
on mountains and moves them still. Thank You for being
the God who spoke in the past and speaks even today.
Thank You for being trustworthy and true. We place our
hope in You—both now and in the future to come. Amen.*

Day 33

Bigger than Fear

Having hope will give you courage.
You will be protected and will rest in safety.
JOB 11:18 NLT

Tossing, turning, sleepless nights: What woman doesn't know these intimately? Our thoughts race with the what-ifs, and fear steals our peace. How precious is God's promise that He will rescue us from nagging, faceless fear and give us courage to "just say no" to anxious thoughts that threaten to terrorize us at our most vulnerable moments. He is our hope and protector. He is bigger than fear. Anxiety flees in His presence. Rest with Him tonight.

Lord, sometimes I am afraid to go to bed. I am afraid of
the endless night, the fears that assail me, the exhaustion
that steals my joy and my hope. On those nights, help
me to continually cry out to You, relinquishing my fears
and laying them at Your feet with thanksgiving. Amen.

Day 34

The Master Stands by Me

*At my preliminary hearing no one stood by me.
They all ran like scared rabbits. But it doesn't
matter—the Master stood by me and helped me spread
the Message loud and clear to those who had never
heard it. I was snatched from the jaws of the lion! God's
looking after me, keeping me safe in the kingdom of
heaven. All praise to him, praise forever! Oh, yes!*

2 TIMOTHY 4:17 MSG

When you give your life to the Master, He has your back. He will always stand by you and be with you. He will give you courage and strength to live your life with grace and truth. Have you put your trust in Him?

Jesus, I choose this day to follow You. I invite You in to be the Lord of my life. I believe that You paid for my sins and cover me with Your righteousness. Fill me with Your love and peace all the days of my life.

Day 35
Heart Changes

Jesus went to Galilee preaching the Message of God: "Time's up! God's kingdom is here. Change your life and believe the Message."
MARK 1:14–15 MSG

What you believe will influence the choices you make. If you believe in gravity, you won't jump from a seventh-story balcony to save time in getting to your hair appointment. If you believe what Jesus says, you'll change the way you live. Jesus often talks about the importance of traits such as honesty, purity, and generosity. Though God's Spirit helps change your heart, it's the daily choices you make that help bring traits like these to maturity.

Lord, help me to trust that my obedience is bearing fruit even when it feels like nothing is really changing. Help me to keep believing that You are working in and through me. Help me to see—without knowing the ending—that You are writing my story. Amen.

Day 36

My Strength and Shield

The LORD is my strength and my shield; my heart
trusts in him, and he helps me. My heart leaps
for joy, and with my song I praise him.
PSALM 28:7 NIV

When you allow Jesus to be your strength, He also becomes Your shield. He is a hiding place. You can always run to Him for anything. With His mighty power, He shields You from anything coming against you. Isaiah 54:17 (NIV) says, " 'No weapon forged against you will prevail, and you will refute every tongue that accuses you. This is the heritage of the servants of the LORD, and this is their vindication from me,' declares the LORD."

Jesus, I'm so thankful that my heritage comes
from You. You cancel attacks and assignments
from the enemy that have been sent my way.
I trust that You will shield and protect me.

Day 37

Life Letter

*These are written so that you will put your faith
in Jesus as the Messiah and the Son of God.
If you have faith in him, you will have true life.*
JOHN 20:31 CEV

The Bible is like a letter from your best friend. In it, God shares how much He loves you, what He's been up to since the creation of the world, and His plans for the future. You're an important part of those plans. The life you live through faith is the letter you write in return. But others will also sneak a peek at your "life letter." The life you live may be the only Bible some people ever read.

*Lord, I want my life to be a living representation of
the gospel—to live with visible repentance and joy.
But often I shudder at speaking the truth. Help me to
be discontent with simply showing; help me tell. For
how will others know if they have not heard? Amen.*

Day 38

Chef D'Oeuvre

Be strong and let your heart take courage,
all you who wait for the LORD.
PSALM 31:24 NASB

Identical eggs can be turned into greasy fried egg sandwiches or an exquisite soufflé. The difference is how much beating they endure.

When life seems to be beating us down, we must remember that we are a masterpiece in progress. The mixing, slicing, and dicing may feel brutal at times, but our Lord has offered us His courage and strength to endure until He is ready to unveil the chef d'oeuvre.

Dear Father, thank You for loving me so much that You
are willing to work tirelessly to make me more like Your
Son. Thank You for not throwing up Your hands at my
mess but instead patiently mixing, kneading, seasoning,
and applying just the right amount of heat. Amen.

Day 39

Armed with Strength

It is God who arms me with strength
and keeps my way secure.
PSALM 18:32 NIV

God arms us with strength. The Passion Translation of this verse says that God wraps us in power. It is through Him alone that we get our strength and power. The Bible uses a lot of imagery to connect us with God more fully. Read this verse again. Now close your eyes and picture what God is saying. Can you see Jesus arming you with strength as He wraps you in His power? What does God want you to know about this verse specifically as it pertains to you? Ask Him. He loves to speak and give clarity to His children.

Lord, I'm so thankful for all the ways You speak
to me. Please show me what You want me to
know about Your strength and power.

Day 40
Into Practice

Truth, righteousness, peace, faith, and salvation
are more than words. Learn how to apply
them. You'll need them throughout your life.
God's Word is an indispensable weapon.
EPHESIANS 6:14–17 MSG

What you do with God's words is ultimately what you decide
to do with God. If you read the Bible for inspiration, without
application, your faith will never be more than a heartwarming
pastime. While it's true the Bible can be a source of comfort,
it's also a source of power and an instrument of change. Invite
God's Spirit to sear the Bible's words into your heart. Then,
step out in faith, and put what you've learned into practice.

Dear Lord, we want to be doers of the Word,
not hearers only. But so often we are content with
a lukewarm, passive faith that shies away from
engagement. Forgive us, and show us how Your
Spirit working in us can turn truth, righteousness,
peace, faith, and salvation into actions. Amen.

Day 41

The Giver of Power and Strength

*Awesome is God from his sanctuary; the God
of Israel—he is the one who gives power and
strength to his people. Blessed be God!*
PSALM 68:35 ESV

Let's pause today to just give glory to the giver of power and strength. He is the awesome God of all creation. He is worthy of all our praise. For the next ten minutes, turn on some praise music and worship Him. Thank Him for all the blessings He has given you. Thank Him for being good to you. When you worship God, even in the midst of hardship, something powerful happens as you turn your head away from yourself and gaze at Jesus. Allow Him to strengthen you through your worship time today.

*Jesus, I praise You. You are Lord over my
life and Lord of all. I'm so thankful
for all that You have done.*

Day 42

Believing without Seeing

*Jesus said, "So, you believe because you've seen
with your own eyes. Even better blessings are in
store for those who believe without seeing."*
JOHN 20:29 MSG

If you're searching for a pair of shoes, you don't rely on a salesperson's description. You want to see them. Try them on. Walk around in them awhile. The same is true when it comes to trying on faith for size. We long to see the one we've chosen to place our faith in. But Jesus says believing without seeing holds its own special reward. Ask Jesus to help you better understand those blessings as you walk in faith today.

*Lord, we know we won't really "see" until we see You
face-to-face. The waiting is hard sometimes; our eyes
strain to see through this dim glass. But we praise You that
our faith grows in the waiting and that You are becoming
more real, true, and beautiful all the time. Amen.*

Day 43

Smiling in the Darkness

The hopes of the godless evaporate.
JOB 8:13 NLT

Hope isn't just an emotion; it's a perspective, a discipline, a way of life. It's a journey of choice. We must learn to override those messages of discouragement, despair, and fear that assault us in times of trouble and press toward the light. Hope is smiling in the darkness. It's confidence that faith in God's sovereignty amounts to *something*. . .something life-changing, life-saving, and eternal.

Lord, when I am despairing and hope seems far away,
help me remember that I always have a choice: to reject
You in that moment or to reach out to You. Forgive me
for the times I just gaze hopelessly at my own navel.
Help me remember to lift my eyes to You. Amen.

Day 44

Glorious Inner Strength

*My response is to get down on my knees before the Father,
this magnificent Father who parcels out all heaven and
earth. I ask him to strengthen you by his Spirit—not a
brute strength but a glorious inner strength—that Christ
will live in you as you open the door and invite him in.
And I ask him that with both feet planted firmly on love,
you'll be able to take in with all followers of Jesus the
extravagant dimensions of Christ's love. Reach out and
experience the breadth! Test its length! Plumb the depths!
Rise to the heights! Live full lives, full in the fullness of God.*
Ephesians 3:16–19 msg

This passage helps us more fully understand the kind of strength
God offers us. It's not a brute strength; it is a glorious inner
strength that shows that the Holy Spirit is alive and at work in us.

Thank You for giving me Your strength, Lord.

Day 45

"Nowhere" Blessings

Turn to face God so he can wipe away your sins,
pour out showers of blessing to refresh you, and send
you the Messiah he prepared for you, namely, Jesus.
ACTS 3:19–20 MSG

Blessings are gifts straight from God's hand. Some of them are tangible, like the gift of a chance acquaintance leading to a job offer that winds up helping to pay the bills. Some are less concrete. They may come wrapped in things like faith, joy, clarity, and contentment appearing seemingly out of "nowhere" amid difficult circumstances. The more frequently you thank God for His blessings, the more aware you'll be of how many more there are to thank Him for.

Dear Lord, help me to continually turn toward
You. Your Word says that when I do, You will wipe
away my sins and pour out showers of blessings
to refresh me. Thank You for enabling me to turn
back to You, over and over again. Amen.

Day 46

Personal Trainer

*Give your burdens to the LORD, and he will take care
of you. He will not permit the godly to slip and fall.*
PSALM 55:22 NLT

It's important for us women to do some heavy lifting as we age. Weight-bearing exercise helps keep our bones strong and our muscles toned. But bearing mental and emotional weight is another story. These don't build us up. They break us down. Allow faith to become your personal trainer when it comes to what's weighing heavily on your mind and heart. God knows how much weight you can bear. Invite Him to carry what you cannot.

*Dear Father, You know the weights of worry, care,
trouble, and trial that I cannot carry on my own; and
You know how often I try to take those burdens out
of Your loving hands. Help me to place them in Your
arms where they belong, over and over again. Amen.*

Day 47
Let Me Be

*Martha. . .you are worried and upset about many
things, but few things are needed—or indeed
only one. Mary has chosen what is better.*
LUKE 10:41–42 NIV

Martha zipped around cleaning, cooking, and organizing.
Meanwhile, Mary sat at Jesus' feet. Many of us think like Martha. Will food magically appear on the table? Will the house
clean itself? We're slaves to endless to-do lists. Our need to
do overwhelms our desire to be. Constipated calendars attest
that we are human doings instead of human beings. But Jesus
taught that Mary chose best—simply to be. Lord, help this
doer learn to be.

*Dear Father, there are so many good and needful things
to do; help me choose, like Mary, what is better. Give me
the courage to simply be still and know that You are God
and that knowing You is my highest good and my most
important priority. Everything else flows from that. Amen.*

Day 48

Take Courage

"No weapon that is formed against you will succeed; and every tongue that rises against you in judgment you will condemn. This [peace, righteousness, security, and triumph over opposition] is the heritage of the servants of the LORD, and this is their vindication from Me," says the LORD.
ISAIAH 54:17 AMP

Have you ever lost your courage? You know, you've decided you were going to do or say something because it was the right thing to do, you worked up the nerve to do it. . .and then you got nervous and backed down? This is what mustering courage in your own strength looks like. It is surface level, and when it comes under even minor attacks, sometimes it fails.

The truth is this: our heritage of courage comes from God.

Lord, I'm excited to learn more about the courage
You give me simply because I'm Your child.

Day 49

Worries into Prayers

Don't fret or worry. Instead of worrying, pray.
Let petitions and praises shape your worries
into prayers, letting God know your concerns.
PHILIPPIANS 4:6 MSG

Sometimes it feels like it's a woman's job to worry. If you can't be assured that all of your loved ones' physical and emotional needs are being met, fretting about them makes you feel involved—like you're loving them, even if you're powerless to help. But you know someone who *does* have the power to help. Anytime you feel the weight of worry, whether it's over someone else's problems or your own, let faith relieve you of the burden. Turn your worries into prayers.

Dear God, it is not my nature to turn my worries into
prayers, but I thank You that Your Spirit working in me
gives me a new nature—one that can lift my worries
up to You as many times as they raise their heads.
Thank You for listening to my concerns. Amen.

Day 50

Why Me?

Moses answered God, "But why me? What makes you think that I could ever go to Pharaoh and lead the children of Israel out of Egypt?" "I'll be with you," God said.
EXODUS 3:11–12 MSG

Sometimes God asks His people to do hard things. But He promises to be with you *in* those hard things. Would you rather be outside of His will and in so doing also be outside His blessing?

Scholars suggest that Moses may have had a speech impediment. He couldn't understand why God would ask *him* to go and speak to the most powerful man around and be a leader to all of Israel. You may be asking God similar questions about the hard thing He's calling you to do. Instead of worrying about what's ahead, trust God's promise for you. He will be with you.

Lord, please help me trust You in this!

Day 51
Head-On

If you had faith no larger than a mustard seed,
you could tell this mountain to move from here to there.
And it would. Everything would be possible for you.
MATTHEW 17:20 CEV

The Bible tells us faith is what moves mountains. Not personal ability. Not perseverance. Not even prayer. These can all play a part in facing a challenge that looks as immovable as a mountain. But it's faith in God's ability, not our own, that's the first step toward meeting a challenge head-on—then conquering it. Remind yourself of what's true about God's loving character and incomparable power. Then move toward the challenge instead of away from it. God's in control.

Lord, You are all-powerful, all-knowing, ever loving,
and always ready to work on our behalf. There is
nothing that surprises You, nothing outside Your
control, nothing that You do not understand completely.
We praise You for being a God in whom our faith
is fully justified. There is none like You. Amen.

Day 52

Small but Mighty

He has. . .exalted the humble.
LUKE 1:52 NLT

God delights in making small things great. He's in the business of taking scrap-heap people and turning them into treasures: Noah (the laughingstock of his city), Moses (stuttering shepherd turned national leader), David (smallest among the big and powerful), Sarah (old and childless), Mary (poor teenager), Rahab (harlot turned faith-filled ancestor of Jesus). So you and I can rejoice with hope! Let us glory in our smallness!

Lord, when we sigh over our smallness and insignificance, help us to see that even our biggest movie stars, political leaders, or cultural trendsetters are minuscule compared to You. Nothing compares to You. And thank You for allowing us to partake of Your glory in Jesus Christ. Amen.

Day 53

When God Says Go

David replied to Abigail, "Praise the Lord, the God of Israel, who has sent you to meet me today! Thank God for your good sense! Bless you. . . . For I swear by the Lord, the God of Israel, who has kept me from hurting you, that if you had not hurried out to meet me, not one of Nabal's men would still be alive tomorrow morning."
1 Samuel 25:32–34 NLT

Have you ever heard the story of Abigail in the Bible? Basically, her husband was a jerk to some important people, and he was about to get dire consequences from the future king of Israel. Abigail became aware of this, and she sprang into action. She courageously went to David and wisely talked him out of his plan for justice. She was a hero to her people. Ask God for courage, like Abigail, to go when He says to go.

Lord, help me to obey quickly when I hear Your voice.

Day 54

Ultimate Makeover

*Don't become so well-adjusted to your culture that
you fit into it without even thinking. Instead, fix your
attention on God. You'll be changed from the inside out.*
ROMANS 12:2 MSG

You're no longer the woman you once were. When you put your faith in God, you experience the ultimate makeover. You're totally forgiven. You're empowered to be able to do whatever God asks. Your old habits lose their grip over you. But continued growth and change is a joint effort between you and God. If there's any area in your life that seems resistant to change, talk to God about it right now—and every morning until change takes place.

*Lord, I praise You that I am not who I once was.
I was condemned; now I am redeemed. I was lost;
now I am found. I was blind; now I can see. The world
looks different, Lord, and sometimes it's painful. Help
me fix my eyes on You, no matter what. Amen.*

Day 55

Pick Me Up, Daddy

Rejoice in hope of the glory of God.
ROMANS 5:2 NKJV

To rejoice means to live joyfully. . .joy-fully. . .full of joy. Joy is a decision we make. A choice *not* to keep wallowing in the mud of our lives. And there will be mud—at one time or another. When spiritual rain mixes with the dirt of fallen people, mud is the inevitable result. The Creator of sparkling sunbeams, soaring eagles, and spectacular fuchsia sunsets wants to lift us out of the mud. Why don't we raise our arms to Him today?

God, when You saved us, You lifted us from the
miry clay of our sin and set us firmly on the rock of
our salvation. That is where we are right now, but
we always forget. Remind us, restore us, renew us.
We long to see ourselves as You see us. Amen.

Day 56

The Lord Your God Is with You

Have I not commanded you? Be strong and courageous.
Do not be afraid; do not be discouraged, for the LORD
your God will be with you wherever you go.
JOSHUA 1:9 NIV

"Joshua fought the battle of Jericho. . . ." Does this bring a childhood Sunday school song to mind? Joshua had a big job ahead of him. It looked impossible. The Israelites finally made it into the Promised Land but saw that it was completely walled off. Why does everything have to be so stinkin' difficult? So God sent an angel with a command and a plan. And Joshua obeyed—even when it sounded crazy (read the story!).

Joshua trusted that God would do what He said He would do. He knew God would be faithful. So when he was told to do something that seemed mighty weird, he did it anyway. And God blessed him for it.

Lord, please give me the courage
to do anything You ask of me.

Day 57
Limitless

LORD, you know the hopes of the helpless.
Surely you will hear their cries and comfort them.
PSALM 10:17 NLT

There's only so much one woman can do. There are limits to your strength, your time, and your capacity to love others well. When you reach the limit of your own abilities, a feeling of helplessness can set in. But being helpless isn't synonymous with being hopeless. God is near. He hears every prayer, every longing, and every sigh. His power, love, and time are limitless. Cry out in faith when you need the comfort of your Father's love.

Lord, we praise You for being a God of love. And not only do You love us, but You are so replete with love that it overflows from us to everyone around us. That's not something we can do in our own strength; when we feel like we can't love any more, You can. Amen.

Day 58

Faith Gives Courage

Then Nebuchadnezzar said, "Praise be to the
God of Shadrach, Meshach and Abednego, who
has sent his angel and rescued his servants! They
trusted in him and defied the king's command and
were willing to give up their lives rather than serve
or worship any god except their own God."
DANIEL 3:28 NIV

The story of the fiery furnace is a miraculous account of faith and courage. These three young men refused to worship anyone but God, knowing fully that the king would have them killed. And of course, the prideful king got angry and had them thrown into the fire. But God came through. The blaze was so hot that the guards who threw them in the fire were killed, but not a hair on the young men's heads was even singed. That's the mighty God we serve—who is still alive and well today.

God, please fill me with the same courage to
stand up for You whenever I'm facing the fire.

Day 59

Life Preserver

Cling to your faith in Christ.
1 TIMOTHY 1:19 NLT

If you were shipwrecked, you'd cling to your life preserver in hope of rescue. Faith is your life preserver in this world. It keeps your head above water in life and carries you safely into God's arms after death. But it takes commitment to keep holding on tight. Emotions rise and fall. Circumstances ebb and flow. But God is committed to you. His love and faithfulness never fail. By holding tightly to your faith, you can weather any storm.

Dear Lord, thank You that at the same time I am holding on to You, You are holding on to me. Your arms are strong and tireless, and I can rest in the knowledge that You will never let me go. Help me press into You deeper and cling tighter. Amen.

Day 60

Keep Breathing, Sister!

As long as we are alive, we still have hope,
just as a live dog is better off than a dead lion.
ECCLESIASTES 9:4 CEV

Isn't this a tremendous scripture? At first glance, the ending elicits a chuckle. But consider the truth it contains: Regardless of how powerful, regal, or intimidating a lion is, when he's dead, he's *dead*. But the living—you and I—still have hope. Limitless possibilities! Hope for today and for the future. Although we may be as lowly dogs, fresh, juicy bones abound. As long as we're breathing, it's not too late!

Dear Lord, thank You that our hope in You never fails.
No matter how often we bark at strangers, snap at our
loved ones, or chew the furniture—no matter how doglike
we act—we still have hope in Your unfailing love. You
forgive and forgive and forgive. In thanksgiving, amen.

Day 61

Courage through Prayer

*When Daniel learned that the decree had been
signed and posted, he continued to pray just as he
had always done. . . . Three times a day he knelt
there in prayer, thanking and praising his God.*
Daniel 6:10 msg

Daniel was an older guy when he was thrown into the lions'
den. He had served God and the land of his exile faithfully over
the years. He was a man of integrity, and the other governors
knew it. The king wanted him to be in charge over the other
lawmakers, and they didn't like that too much. So they plotted
against him, even though Daniel was a good guy who had done
nothing wrong. That's what started the whole lions' den fiasco.
Daniel trusted His faithful God, though. And no harm came
to him. He was courageous because of the time he spent with
God in prayer. Because he was close to God, he didn't cave to
peer pressure.

Lord, what do You want to teach me in this story?

Day 62
Follow Through

By faith the walls of Jericho fell, after the army
had marched around them for seven days.
HEBREWS 11:30 NIV

In the Bible, God asked people to do some pretty unlikely things. Build an ark. Defeat Jericho by walking around its walls. Battle a giant with a slingshot. But when people are committed to doing what God asks, amazing things happen. What's God asking you to do? Love someone who seems unlovable? Break a bad habit? Forgive? Commit yourself to follow through and do what God asks. Through faith, you'll witness firsthand how the unbelievable can happen.

Dear Father, You never ask us to do something that
You do not also give us the means to accomplish.
All is possible through Your strength. Help us see not
impossibilities but miraculous possibilities! Walls, giants,
and sins will fall at the sound of Your voice. Amen.

Day 63

Awed

The Fear-of-God builds up confidence,
and makes a world safe for your children.
PROVERBS 14:26 MSG

When the Bible talks about the *fear of God*, it's more about awe than alarm. Through faith, we catch a glimpse of how powerful God really is and how small we are in comparison. Yet the depth of God's love for us rivals the enormity of His might. Regardless of the troubles that may surround you or what you see on the evening news, you can be confident that God remains in charge, in control, and deeply in love.

Dear Lord, we stand amazed at Your provision, Your
promises, Your protection, and Your peace. There is
nothing in this life we need to fear but You. Help us to
stand with confidence, awe, reverence, and holy fear on the
rock of our salvation. In praise and thanksgiving, amen.

Day 64

It's a Mystery

This is the day which the LORD has made;
let's rejoice and be glad in it.
PSALM 118:24 NASB

Let's face it, girls, some mornings our rejoicing lasts only until the toothpaste drips onto our new shirt or the toast sets off the fire alarm. But the mystery of Jesus-joy is that it's not dependent on rosy circumstances. If we, after cleaning the shirt and scraping the toast, intentionally give our day to the Lord, He *will* infuse it with His joy. Things look much better through Jesus-joy contact lenses!

Lord, seeing as You see doesn't come naturally. Joy is something the scripture says we have to put on. We have to choose it. Forgive us for choosing other things when Your joy is right there, waiting to transform our days. Thank You that it is a supernatural choice with actual results! Amen.

Day 65

Path to Contentment

You're blessed when you're content with just who you are—
no more, no less. That's the moment you find yourselves
proud owners of everything that can't be bought.
MATTHEW 5:5 MSG

Being content with what you have is one thing. Being content with who you are is quite another. This kind of contentment isn't complacency. It doesn't negate the importance of striving for excellence or encouraging growth and change. It means being at peace with the way God designed you and the life He's given you. This kind of contentment is only available in daily doses. Through faith, seek God and His path to contentment each and every morning.

Lord, thank You that contentment isn't having what
we want but wanting what we have. And when
we accept Jesus Christ as our Savior, Your Word
promises that You give us everything we need for life
and godliness. Everything. Everything! Remind us
daily that what we need is already ours. Amen.

Day 66

Courage from Our Mighty God

Hezekiah rallied the people, saying, "Be strong!
Take courage! Don't be intimidated by the king of
Assyria and his troops—there are more on our side
than on their side. He only has a bunch of mere men;
we have our GOD to help us and fight for us!"
2 CHRONICLES 32:7–8 MSG

Hezekiah was facing war. The people of his land needed courage for battle. Hezekiah reminded them of who their God was. And when things looked dire, they cried out to God in prayer. And do you know what God did? He sent an angel who completely wiped out the opposing army. Just like that, it was done.

Second Chronicles 32:22 (NIV) says, "So the LORD saved Hezekiah and the people of Jerusalem. . . . He took care of them on every side." Other versions of the Bible say that God gave them rest and peace on every side.

Lord, I need some help fighting a few
battles. Please do what only You can.

Day 67

Nothing to Fear

The blood of Jesus gives us courage to enter the most holy place by a new way that leads to life! And this way takes us through the curtain that is Christ himself.
HEBREWS 10:19–20 CEV

Imagine standing before a holy, almighty, and perfect God and being judged for how you've lived your life. Every mistake, poor choice, and moment of rebellion would be exposed. Sounds downright terrifying, doesn't it? But through our faith in Jesus, we have nothing to fear. We stand faultless and forgiven. Through Christ, we can gather the courage to look at ourselves as we really are, faults and all, without shame. Being wholly loved gives us the courage to fully live.

Lord, this is amazing grace, and it is offered to us by no other system, god, or religion. Only through Jesus Christ, whose flesh was torn for our salvation, can we be rightly seen, fully known, totally loved, and completely forgiven. We are redeemed! Praise the Lord! Amen.

Day 68

Brick by Brick

So then faith cometh by hearing,
and hearing by the word of God.
ROMANS 10:17 KJV

Words are powerful. They cut. They heal. They confirm. God uses His Word to help us, to mold us, to make us more like Him. Our faith is built from the bricks of God's Word. Brick by brick, we erect, strengthen, and fortify that faith. But only if we truly listen and *hear* the Word of God.

Father, we can listen to Your Word for years without truly hearing it. Only Your Spirit can enliven it and us so that it becomes the living Word. We pray that our hearts would be softened to the message in Your Word and that our wills would be conformed to it. Amen.

Day 69

Remember

God, who delivered me from the teeth of the lion and the claws of the bear, will deliver me from this Philistine.
1 Samuel 17:37 MSG

Verses 32–33 tell more of the story: "'Master,' said David, 'don't give up hope. I'm ready to go and fight this Philistine.' Saul answered David, 'You can't go and fight this Philistine. You're too young and inexperienced—and he's been at this fighting business since before you were born.'"

As you journey in faith, it becomes so important to remember God's faithfulness to you specifically. David wasn't afraid of Goliath because he remembered how God had been faithful to him in the past. Take some time to begin writing down the big things you've seen God do in your life. Write dates if you know them, or your best guess. Then commit to journaling how God shows up in your life. And when life seems hard and you need some more courage and faith, you have a black-and-white reminder of how God has been real to you.

Lord, thank You for Your great faithfulness to me.

Day 70

Whatever Needs Done

When I asked for your help, you answered
my prayer and gave me courage.
PSALM 138:3 CEV

Why do you need courage today? To apologize? To forgive? To break an old habit? To discipline a child? To love in the face of rejection? Courage isn't just for times when you're facing grievous danger. Any time you face difficult, unpredictable situations, it takes courage to move forward. When you're tempted to turn away from your problems, let faith help you turn toward God. With Him, you'll find the courage you need to do whatever needs to be done.

God, sometimes the things You ask me to do seem too hard.
Forgive me for doubting You. . . . I need to trust that what
You call me to do, You will also equip me to accomplish.
I can do all things through You. Give me the courage to step
out in faith, knowing Your hands are holding me up. Amen.

Day 71
Roots

"There is hope for your future," declares the LORD,
"And your children will return to their own territory."
JEREMIAH 31:17 NASB

Prodigal. The word alone evokes an involuntary shudder.

Most of us know parents whose children have left home in the throes of rebellion. Some of us *are* those parents. After years of protecting and nurturing our children, heartache replaces harmony, panic supersedes pride. Broken relationships shred our hearts with their jagged edges. But the great peacemaker declares that prodigals will one day return to their roots. One of His greatest parables reinforces that hope (Luke 15).

Dear Father, we were all prodigal children until we
accepted the once-for-all sacrifice of Your Son. We praise
You that You are not willing that any should perish but that
all come to a saving knowledge of Jesus Christ. And we
will continue to pray, in faith, until that day comes. Amen.

Day 72

Powerful and Courageous Women

*Now Deborah, a prophetess, the wife of Lappidoth,
was judging Israel at that time. She used to sit [to hear
and decide disputes] under the palm tree of Deborah
between Ramah and Bethel in the hill country of Ephraim;
and the Israelites came up to her for judgment.*

JUDGES 4:4–5 AMP

Deborah was a wise, God-fearing woman. People flocked to her to hear her advice. She became one of the judges over all of Israel. She urged the Jewish people to repent and turn back to God. God greatly values and uses women in ministry. God set Deborah up as a judge over all of the Jewish people, not just over other women. She commanded an army to go into battle, and God gave them victory.

God has great plans for you as a woman. Those plans are likely more than you could imagine.

*Father God, I will follow where You lead, even if it
seems beyond my capabilities, because You are with me.*

Day 73

Right Here, Right Now

Better is one day in your courts than a thousand elsewhere.
PSALM 84:10 NIV

It's fun daydreaming about places you'd like to visit, goals you'd like to accomplish, or the woman you hope to mature into—someday. But God's only given you one life. Chances are, you'll have more dreams than you'll have days. Instead of living for "someday," God challenges you to put your heart into today. Whether you're sunning on vacation or scrubbing the kitchen floor, the God of the universe is right here with you. That's something worth celebrating!

Lord, thank You for the dreams and goals You have given me and how they motivate me to persevere. Thank You also for this present moment and how I can become more like You right now. Help me live well in the tension between "already" and "not yet." Amen.

Day 74

Jets and Submarines

*No power in the sky above or in the earth below—indeed,
nothing in all creation will ever be able to separate us from
the love of God that is revealed in Christ Jesus our Lord.*
ROMANS 8:39 NLT

Have you ever been diving amid the spectacular array of vivid
color and teeming life in the silent world under the sea? Painted
fish of rainbow hues are backlit by diffused sunbeams. Multi-
textured coral dot the gleaming white sand. You honestly feel
as if you're in another world. But every world is God's world.
He soars above the clouds with us and spans the depths of the
seas. *Nothing* can separate us from His love.

> *Dear Lord, I praise You because Your love is so strong
> that nothing can separate me from it. No sin that I
> commit, no terrible thought, nothing done to me by
> someone else. Your love is greater, stronger, deeper,
> wider, and longer than anything in all creation. Amen.*

Day 75

When the Ship Goes Down

But take courage! None of you will lose your lives, even though the ship will go down. For last night an angel of the God to whom I belong and whom I serve stood beside me, and he said, "Don't be afraid, Paul. . . . God in his goodness has granted safety to everyone sailing with you."
ACTS 27:22–24 NLT

Life can be so hard sometimes. We lose a loved one or a relationship, or a ministry we loved comes to an unexpected end. Sometimes the ship goes down. But God is always faithful to His people. He is with you in the storm, and He is with you when the ship goes down. Even if you were part of the cause. Psalm 34:18 (NIV) says, "The LORD is close to the brokenhearted and saves those who are crushed in spirit." When your courage has gone down with the ship, lift up your head. God is close.

Be close to me, Lord Jesus.

Day 76

Into His Arms

Love the LORD your God, walk in all his ways,
obey his commands, hold firmly to him, and serve
him with all your heart and all your soul.
JOSHUA 22:5 NLT

Every walk you take is a series of steps that moves you forward. Each day you live is like a single step, moving you closer to—or farther away—from God. That's why it's good to get your bearings each morning. Through reading the Bible and spending time with God in prayer, you'll know which direction to take as you continue your walk of faith. Day by day, God will guide you straight into His arms.

Dear Father, thank You for waking me early this
morning to read Your Word. Thank You for the promise
of a beautiful day and the sun streaming in through
the windows. Thank You for these quiet minutes to
draw near to You and reorient my feet. Amen.

Day 77

God Shows Up

"O Lord, answer me! Answer me so these people will know that you, O Lord, are God and that you have brought them back to yourself." Immediately the fire of the Lord flashed down from heaven and burned up the young bull, the wood, the stones, and the dust. It even licked up all the water in the trench!
1 KINGS 18:37–38 NLT

Elijah didn't have any doubt in the almighty power of God. God spoke to Elijah, and Elijah obeyed. He knew God's voice. God told Elijah to go see King Ahab and point out his sins. Elijah told the truth with courage and boldness that came because He trusted God. God showed up, just like Elijah knew He would.

Where do you need God to show up in big ways right now? Talk to Him about this.

Lord, please give me boldness like
Elijah and an unwavering faith in You.

Day 78

Root of Desire

Wherever your treasure is, there the
desires of your heart will also be.
MATTHEW 6:21 NLT

What does your heart long for? If you look at the root of
every deep desire, you'll find something only God can fill.
Love, security, comfort, significance, joy. . . Trying to satisfy
these desires apart from God can only yield limited success.
God is the only one whose love for you will never waver.
You're His treasure; and His desire is to spend eternity with
you. As your faith grows, so will your desire to treasure Him
in return.

Lord, sometimes it takes a work of Your Spirit for us to
see the true roots of our desires. We long for wisdom
to desire rightly, and we long for the bravery to look
directly at our desires and say, "Not my will, but Yours."
Help us to treasure You above all else, Father. Amen.

Day 79

Let the Sun Shine In

*Come to me, all you who are weary
and burdened, and I will give you rest.*
MATTHEW 11:28 NIV

Nothing chokes hope like weariness. Day-in-and-day-out drudgery produces weariness of body, heart, and soul. It feels like dark clouds have obscured the sun and cast us into perpetual shadow. But Jesus promised rest for our weary souls, respite from our burdens, and healing for our wounds. . .*if* we come to Him. The sun isn't really gone; it's just hidden until the clouds roll away.

*Dear Lord, I want to know what it really means to
come to You. I don't want to make You just another
item on my to-do list, to be squeezed in between grocery
shopping and carpooling. I want to orient my life
around You. You promise rest. . .if I come. Amen.*

Day 80

Courage in Truth

*Do not rebel against the LORD, and don't be
afraid of the people of the land. They are only
helpless prey to us! They have no protection,
but the LORD is with us! Don't be afraid of them!*

NUMBERS 14:9 NLT

Joshua and Caleb, leaders of the Israelites, faced their people in a dangerous situation. These people they knew well—their friends, family, and neighbors—formed an angry mob, turning on them and preparing to stone them. Joshua and Caleb pleaded with these people to return to the ways of God, but they wouldn't listen, and again God gave them dire consequences.

When God asks you to stand up for Him and His ways among your friends and family, He will give you the courage to speak truth in love, regardless of the way things turn out. You will be blessed for your obedience even if your words aren't valued by others.

Lord, please give me courage to speak up for Your truth.

Day 81
Motivation

You are no longer ruled by your desires,
but by God's Spirit, who lives in you.
ROMANS 8:9 CEV

In preparing to play a role, an actress asks herself, "What's my character's motivation?" That's because what motivates us moves us. If a character's desire is to be admired, rich, beautiful, or loved, that will influence her decisions and actions. As you allow God to work in and through you, your desires begin to fall in line with His. There's no longer any need to act. You're free to be exactly who God created you to be.

Dear Father, we know nothing of the humility of infinite
perfection rubbing shoulders with sinful humanity,
but we praise You for being willing to live among us
and in us. Give us the desire to know You better and
be more fully conformed to Your image. Amen.

Day 82

Devoted to Others

Women who claim to be devoted to God should make themselves attractive by the good things they do.
1 TIMOTHY 2:10 NLT

Our devotion to God leads us to be more devoted to others. That's because God's Spirit is at work in us, encouraging us to do what's right. When we keep our promises, weigh our words, and offer a helping hand with no expectation of reward, we are loving God by loving others. Our faith-filled devotion to God brings out the best in us, while at the same time blessing those around us.

Lord, forgive me for not living out my devotion to You with actions. Forgive me for my laziness, selfishness, and unkindness. Forgive me for giving to others with any thought to my own profit. Help me seek to bless others in all I do, regardless of the cost or the reward. Amen.

Day 83
Battle Plan

I sought the LORD and He answered me,
and rescued me from all my fears.
PSALM 34:4 NASB

There is nothing more wasteful than fear. Fear paralyzes, destroys potential, and shatters hope. It's like an enemy attacking from our blind side. But we don't have to allow fear to defeat us. It's a war that we can win! First comes earnest prayer, then comes change. God will deliver us from our fears if we seek Him and follow His battle plan.

Dear Lord, over and over in Your Word, You say,
"Do not fear." Thank You for never giving us commands
that You don't also give us the means to obey. Help me
to hate my fears instead of using them as excuses. Help
me to seek You. . .and expect You to answer. Amen.

Day 84

Courage and Obedience

*So Noah did everything exactly
as God had commanded him.*
GENESIS 6:22 NLT

You know the story of Noah and the ark. He needed a crazy amount of courage to obey God and do what He said. God was very clear and gave Noah specific details to follow. When God wants you to obey Him, ask Him to clarify. Sometimes it will be quite obvious with specific direction from God's Word. Sometimes you will have to ask God to reveal His will for you in a certain situation or relationship. God loves to speak to His children, and He will direct you if it is truly something He wants you to do. Do you believe that? Noah obeyed God down to the intricate details, and God blessed him for it.

*Lord, please reveal Yourself to me. Help me to know what
to do in this situation. And give me the courage to obey.*

Day 85

Transformed Doubts

Immediately the father of the child cried out and
said with tears, "Lord, I believe; help my unbelief!"
MARK 9:24 NKJV

Entrusting friends and family to God's care isn't always easy. One reason is that as women, we're born caretakers—and we doubt anyone can care for those we love as well as we do. Faith assures us that God is the only perfect caregiver. When we worry about someone, we're doubting God's love, power, and plan for that person's life. Bring every doubt and worry to God in prayer. Then allow Him to transform your doubts into faith.

Dear Lord, You know how my faith rises and falls
like the waves of the sea. Sometimes I trust, but more
often I try to soldier on under my own power. Forgive
me for trying to carry the burdens that only You can.
Help me give those burdens back to You. Amen.

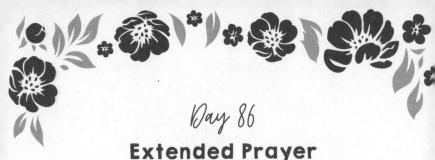

Day 86

Extended Prayer

I answered them, "The God of heaven [has appointed
us for His purpose and] will give us success;
therefore we His servants will arise and build."
NEHEMIAH 2:20 AMP

Nehemiah cried out to God for help in bold prayers. He heard that his city and his friends were in trouble, and he grieved and prayed some more. He prayed and prayed before he acted. He received great courage from God through his prayers, and then he went into action.

Spend some extended time with God in prayer today. Tell Him what is on your heart, ask for His guidance, and wait for an answer. Repent of putting God in a box, and allow Him to speak to you in whatever way He chooses. Then arise and do as He says.

Lord, You are more powerful than I could ever
imagine. Forgive me for the limits I've put on You in
the past. Speak to me and give me courage to obey.

Day 87
Go for It!

When everything was hopeless, Abraham believed anyway, deciding to live not on the basis of what he saw he couldn't do but on what God said he would do.
ROMANS 4:18 MSG

"You can't do that. It's impossible." Have you ever been told this? Or just thought it because of fear or a previous experience with failure?

This world is full of those who discourage rather than encourage. If we believe them, we'll never do anything. But if we, like Abraham, believe that God has called us for a particular purpose, then we'll go for it despite our track records. Past failure doesn't dictate future failure. If God wills it, He fulfills it.

Dear Lord, You are the God of the impossible. We praise You when we remember how many times You have rescued, healed, and intervened in impossible ways for Your people. Help us to live hopefully in the light of Your promises, knowing nothing is impossible for You. Amen.

Day 88

Supernatural Strength

Then the hand of the Lord came upon Elijah [giving him supernatural strength]. He girded up his loins and outran Ahab to the entrance of Jezreel [nearly twenty miles].
1 KINGS 18:46 AMP

Elijah obeyed God, but not everyone was happy with him for speaking truth and exposing their wickedness. The king's wife, Jezebel, wanted him dead. But God protected His courageous and obedient child. He gave Elijah superhuman strength and speed to outrun Ahab's horses. You may hear some Christians say that God doesn't work that way anymore. But the Bible says that God is the same yesterday, today, and forever (Hebrews 13:8). The same protector and sustainer of Elijah is your God too. He can do what He has always done and show up in powerful ways in your life.

Lord, forgive me for the times I've doubted Your power in my life. I want to know You and trust You more.

Day 89

Erased!

*When you ask for something, you must have
faith and not doubt. Anyone who doubts is like
an ocean wave tossed around in a storm.*
JAMES 1:6 CEV

You wouldn't ask a gardener to trim your hair or a house painter to paint your nails. When you ask someone to do something, you ask only those who you believe can actually do what needs done. God can do anything that's in line with His will. If you pray without expecting God to answer, doubt is derailing your faith. Ask God to help you understand the "whys" behind your doubts. He can help you erase each one.

*Dear God, when we truly understand Your power and
love, we will no longer doubt. You can do anything!
Help me to pray in faith, knowing You are always
hearing and answering, even if sometimes Your
answer is "no" or "not yet." We rest in that. Amen.*

Day 90

Nothing More than Feelings

LORD, sustain me as you promised, that I
may live! Do not let my hope be crushed.
PSALM 119:116 NLT

Whatever our foe—unemployment, rejection, loss, illness—we may feel beaten down by life. Hope feels crushed by the relentless boulder bearing down on our souls. We feel that we can't possibly endure another day. Yes, we feel, we *feel*. But feelings are often deceiving. God promises to sustain us, to strengthen us, so that we might withstand that massive rock. We can trust Him. He will not allow us to be crushed!

Lord, we are lost, crushed, abandoned, alone. It's all
too hard, and You feel so far away. Sustain us, dear
Father, in this hardship. Only You can keep our hope
alive and the flame of our faith from going out. We
trust You and cling to You in this darkness. Amen.

Day 91

Courage from the Source

I look up to the mountains; does my strength come from mountains? No, my strength comes from GOD, who made heaven, and earth, and mountains. . . . GOD guards you from every evil, he guards your very life. He guards you when you leave and when you return, he guards you now, he guards you always.
PSALM 121:1–2, 7–8 MSG

Remember, you won't get courage by digging down deep in your own strength. Supernatural strength and courage come from God alone. He is the very source of life and power. Does this mean you can stop trying to manipulate circumstances and people to protect yourself? Yes. God is your guardian and protector. He will give you the courage and strength to do whatever it is He is asking of you. And sometimes it is simply just to rest in Him.

You are my source of courage and strength, Lord. Help me to rest in that truth.

Day 92
You're Loved

The humble will see their God at work and be glad.
Let all who seek God's help be encouraged.
Psalm 69:32 nlt

Asking someone for help can be humbling. Even if that someone is a close girlfriend. But if she agrees to assist you and actually comes through for you, you can't help but be encouraged. Knowing someone reached out to you means that person cares. It means you matter. You're loved. Know that God's help means the very same thing. He cares for you because He cares *about* you. Let that fact encourage you in your faith today.

Lord, thank You for our friends who have acted
as the hands and feet of Jesus. They are Your
instruments in our lives, and we praise You for
Your care of us through their ministry. Help us to
ask for help as easily as we give it. Amen.

Day 13

Path to Heaven

*God loved the people of this world so much that he
gave his only Son, so that everyone who has faith
in him will have eternal life and never really die.*
JOHN 3:16 CEV

Eternal life doesn't begin after you die. It begins the day you put your faith in Jesus' love. Right now, you're in the childhood of eternity. You're learning and growing. Like a toddler trying to master the art of walking, you may wobble a bit at times. But if you fall, God helps you get back on your feet again. Once your faith sets you on the path toward heaven, nothing—absolutely nothing—can prevent you from reaching your destination.

*Dear Father in heaven, help us keep walking forward,
toward You, until our faith eventually becomes sight
in eternity. Forgive us for our wobbles, missteps, and
wrong turns. Thank You for helping to keep our eyes
fixed on You and the sure promise of eternal life. Amen.*

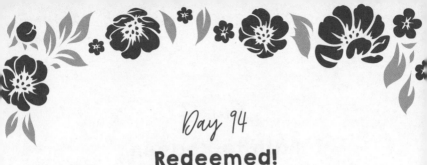

Day 94

Redeemed!

O Israel, hope in the LORD; for with the LORD there is lovingkindness, and with Him is abundant redemption.

PSALM 130:7 AMP

The psalmist knew Israel had a rotten track record. Throughout Old Testament history, God miraculously delivered the Israelites from trouble repeatedly; and they would gratefully turn to Him, only to eventually slip again into rebellion and more trouble. Sounds a lot like you and me, doesn't it? But thankfully, ours is a redemptive God—a God who offers abundant lovingkindness and forgiveness. A God of second chances—then and now.

Dear God, we look at Israel and think, How could they? How could they have seen the miracles and continued in rebellion and forgetfulness? Forgive us, Lord, for thinking we are any different. Forgive us our wickedness, rebellion, and sin. Thank You for Your endless, loving faithfulness. Amen.

Day 95

You Are Holy and Dearly Loved

Therefore, as God's chosen people, holy and dearly loved, clothe yourselves with compassion, kindness, humility, gentleness and patience.
COLOSSIANS 3:12 NIV

"God is no respecter of persons" (Acts 10:34 KJV). Other versions say that God doesn't show favoritism. There's an old saying that every man puts his pants on one leg at a time. What does all that have to do with your spiritual life? It means that God values you just as much as all the famous Christians and the heroes from the Bible. No one Christian is better or more valuable in God's kingdom than you are. Surprised? You are a dearly loved child of God, and everything you do has value and purpose in His kingdom. Not because of anything you have done or could ever do on your own, but simply because you're God's beloved daughter, God's chosen one—holy and blameless because of Jesus.

Lord, help me to believe what You say about me!

Day 96

A Happy Ending

*Because you kept on believing, you'll get what
you're looking forward to: total salvation.*
1 PETER 1:9 MSG

Your salvation comes through faith in Christ. The end result of that salvation is eternal life. Though you're not home in heaven yet, that doesn't mean its existence isn't relevant to you right now. Holding on to your hope of heaven gives you an eternal perspective. It frees you from the fear of death, inspires you to tell others about God's everlasting love, and reminds you that no matter what you face in this life, you're guaranteed a happy ending.

*Lord, You are so good. Thank You for the gift of salvation
that was ours the moment we believed! That present
reality and future hope is a gift You offer to everyone,
and we pray that You would give us the strength
and courage to share that gift with others. Amen.*

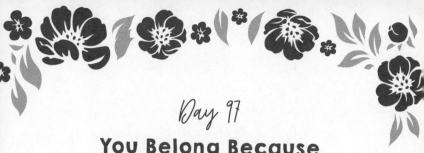

Day 97

You Belong Because
God Says You Do

*I want you to think about how all this makes you more
significant, not less. A body isn't just a single part
blown up into something huge. It's all the different-
but-similar parts arranged and functioning together.*
1 CORINTHIANS 12:14–15 MSG

Have you ever walked into a room and felt instantly like you
didn't belong? That can happen in groups and in social settings,
but it should never happen in church. Why? Because you belong
there. And you belong because God says you do. As believers
in Jesus Christ, we are all part of one body—the body of Christ.
We all need each other to move and grow. The next time you
feel intimidated or unwelcome at a church function, ask Jesus
to give you courage and show you your purpose there. If you
are feeling unwelcome, maybe it's because God wants you to
help welcome others!

Lord, thanks for giving me a place in Your body.

Day 98

A Glimpse of God

In the morning, L<small>ORD</small>, you hear my voice; in the morning
I lay my requests before you and wait expectantly.
P<small>SALM</small> 5:3 <small>NIV</small>

If you're expecting an important package, you're often on the lookout for the mail carrier. You peek out the window. Listen for footsteps. Check the mailbox. When you pray, are you on the lookout for God's answers? Not every answer will be delivered when, where, and how you expect. So keep your eyes open and your heart expectant. Don't miss out on the joy of catching a glimpse of God at work.

Dear Lord, thank You for the reminder in the
psalms that You hear my voice. I am known by You
and loved—so I can wait patiently and be certain that
You will answer in the way that is best for me. What
assurance! What peace! In praise and thanksgiving, amen.

Day 99

Mr. Clean for the Soul

*As far as the east is from the west, so far has
He removed our wrongdoings from us.*
PSALM 103:12 NASB

Dirty little secrets. We all have them. Exposing them is a popular theme for television shows these days. But we don't have to wallow in the muck of our past. God has promised to wash us clean of our dirty little secrets and remove them as far as the east is from the west when we repent of our wrongdoings and ask him for forgiveness. An immaculate and sparkling fresh start—redemption is Mr. Clean for the soul!

*Father, we praise You for Jesus' example of sinlessness
in thought, deed, and word. That is a standard of
perfection that we can never meet, but because He took
our sins as His own, we can rest in His righteousness.
Thank You for paying the price we could not. Amen.*

Day 100

You Are Blameless and Pure

*May God himself, the God of peace, sanctify you through
and through. May your whole spirit, soul and body be
kept blameless at the coming of our Lord Jesus Christ.
The one who calls you is faithful, and he will do it.*
1 THESSALONIANS 5:23–24 NIV

Making mistakes is part of life. We teach this to our children, but why are we so hard on ourselves when we mess up? When you start criticizing or attacking yourself for making a mistake, remember the truth of who God says you are. Because of Jesus' death and resurrection, God sees you as blameless and pure. Jesus already took on all your sin and shame, and He paid for it dearly, once and for all. So you can face any accusation, whether it's from yourself or others, with truth from God's Word.

*Lord, help me to defeat any lies about
myself with truth from Your Word.*

Day 101

The Unexpected

Jesus replied, "Why do you say 'if you can'?
Anything is possible for someone who has faith!"
MARK 9:23 CEV

What can we expect from God? The unexpected. Many people who came to Jesus asked to be healed. But how Jesus healed them was never the same. He put mud in a blind man's eyes. A bleeding woman merely touched His robe. Sometimes Jesus only spoke—and healing happened. Coming to God in faith means you can expect that He will act. He promises He'll respond to your prayers. How? Anticipate the unexpected.

Lord, I am so glad that You are a living, active God.
You're not a genie compelled to appear when the lamp
is rubbed; You're not a heavenly slot machine that
spills out answers at random. You are always listening,
always loving, and always answering. Amen.

Day 102

You Can Lift Your Head

*I sought the LORD, and he answered me; he delivered
me from all my fears. Those who look to him are
radiant; their faces are never covered with shame.*
PSALM 34:4–5 NIV

Feeling inferior to certain people comes easily, especially
when you haven't dealt with your past. Jesus came to set you
free. Take a minute and look up Luke 4:18–19. There Jesus
tells us why he came. Close your eyes in prayer and imagine
Jesus saying these words directly to you. He came to bring *you*
good news. To proclaim freedom, to give you new eyes, to set
you free. He doesn't want you to be held captive by your past.
What do you need Him to free in you today so that you can
lift your head again?

*Jesus, thank You for coming for me.
Please free me from the grip of my past.*

Day 103
Perfectly

Your kingdom is an everlasting kingdom, and your dominion endures through all generations. The LORD is trustworthy in all he promises and faithful in all he does.
PSALM 145:13 NIV

God's faithfulness to you never falters. It began before you were born and will last far beyond the day you die. Nothing you do, or don't do, can adversely affect His love and devotion. This kind of faithfulness can only come from God. Those who love you may promise they'll never let you down, but they're fallible. Just like you. Only God is perfect—and perfectly trustworthy. What He says, He does. Today, tomorrow, and always.

Dear Lord, forgive us for putting our trust in things other than You: in people, abilities, situations, money, habits, histories. All those things will fail us. Only You are the one true God, from everlasting to everlasting, faithful to every promise You have ever made. Amen.

Day 104

Questions and Answers

*And the Scriptures were written to teach
and encourage us by giving us hope.*
ROMANS 15:4 CEV

What do you do when facing a perplexing problem? Ask a family member? Consult a friend? Turn to the Internet?

God's Word is brimming with answers to life's difficulties, yet it's often the last place we turn. God speaks to us today through the lives of trusting Abraham, brokenhearted Ruth, runaway Jonah, courageous Esther, female-leader Deborah in a male-dominated society, beaten-down Job, double-crossing Peter, and Paul, who proved people *can* change.

*Dear Lord, You hold all the answers to every question
that has ever been asked—or ever will be asked. Nothing
surprises, shocks, or confounds You. Thank You for being
the Alpha and Omega, the beginning and the end. Help me
to look to You—and into Your Word—for answers. Amen.*

Day 105

You Are Royalty

*You are a chosen people. You are royal priests, a holy
nation, God's very own possession. As a result, you
can show others the goodness of God, for he called
you out of the darkness into his wonderful light.*

1 PETER 2:9 NLT

Can you picture yourself walking before your king? You are His
princess. Ephesians 3:12 (NIV) says, "In him and through faith
in him we may approach God with freedom and confidence."
All because of Jesus and the price He paid to rescue, redeem,
and free you. In the courts of heaven, you have a place of high
honor. God will receive you with delight because He loves you
so much. Nothing you could ever think or do will change that.
All because of Jesus. Believe it.

*Lord, I'm continually amazed at the truth
of who You are and who I am in You.*

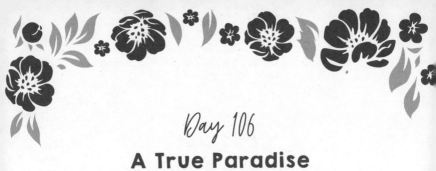

Day 106

A True Paradise

*If we confess our sins to God, he can always be
trusted to forgive us and take our sins away.*
1 JOHN 1:9 CEV

Faith and forgiveness are two sides of the same coin. You cannot hold on to one without embracing the other. If you believe Jesus loves you so much that He would pay the penalty for your sins with His own life, then you must also believe that He wouldn't hold those sins against you any longer. If you're feeling guilty, talk to God. Your feelings are not always truth tellers. God's forgiveness is what makes spending eternity with Him a true paradise.

*Father, thank You for the size of Your forgiveness: as far
as the east is from the west, as deep as the ocean, as
wide as the sky. And You don't just forgive, but You take
our sins away as though they had never been. Help us
to rest and rejoice in Your undeserved mercy. Amen.*

Day 107

Free to Be

*I will walk in freedom, for I have
devoted myself to your commandments.*
PSALM 119:45 NLT

Without rules, what sounds like freedom can be chaos. Take driving, for instance. You need a license to operate a motor vehicle. That's not because the DMV is worried about your being a woman driver. It's because traffic flows "freer" when everyone knows and follows the rules. The same is true when living a life of faith. God's commandments help us build stronger relationships. We're freer to be ourselves—and love God and others well—when we follow His rules.

*Dear Lord, thank You that Your Word brings abundant
life, not restriction. Your fences bring us complete freedom
within the bounds of Your will. Your commandments
were only ever given for our good: to point us to the
Savior, Jesus Christ, who obeys perfectly. Amen.*

Day 108
One for All

*All of you are part of the same body. There is only
one Spirit of God, just as you were given one hope
when you were chosen to be God's people.*
EPHESIANS 4:4 CEV

Remember the motto of the Three Musketeers? "All for one
and one for all." Christ followers should have the same sense
of unity, for we are bound together by eternal hope, the gift of
our Savior. Feeling *with* and *for* each other, we'll cry tears of
joy from one eye and tears of sadness from the other. Loneliness is not an option. Take the first step. Reach out today—
someone else's hand is reaching too.

*Lord, sometimes we are afraid to reach out. We are
afraid of being needy, of being a nuisance, or of being
rejected. Forgive us for not trusting Your body. Help
us to see those hands reaching out to us as Your hands
and to clasp them without fear. In Jesus' name, amen.*

Day 109

You Are a Friend of God

I no longer call you servants, because a servant
does not know his master's business. Instead, I have
called you friends, for everything that I learned
from my Father I have made known to you.
JOHN 15:15 NIV

As a follower of Jesus, you become His friend as you grow in relationship. Jesus lets you in on things. He wants to be around you. He delights in you. The triune God comes and makes His home in you, and you can experience Him through Father, Son, and Holy Spirit. His ways are beyond anything you can fathom. It's mind-boggling to think that the Creator of the universe wants to befriend you. Today, spend time in prayer asking Jesus what He thinks about your friendship. Are you a good friend? Is He? Ponder this today in prayer.

Jesus, I invite You to be my best friend.
Help me to honor You in that spot in my life.

Day 110

Key to Freedom

*The Scriptures declare that we are all prisoners
of sin, so we receive God's promise of freedom
only by believing in Jesus Christ.*

GALATIANS 3:22 NLT

Imagine being locked in prison for years. You're guilty, hopeless, and helpless. Then a beloved friend volunteers to take your place. You're set free as another woman takes your punishment as her own. How much do you value the cost of your freedom? In essence, this is what Christ did for you. When you place your faith in Him, you're handed the key to freedom. Honor Jesus' gift by living a life worthy of such sacrifice.

*Lord, I would live differently if there actually were
another woman in jail in my place. I would continually
tell of her love and sacrifice for me. Her praises would
always be on my lips. You went to jail for me, Jesus!
Whom the Son sets free is free indeed. Amen.*

Day 111
Make Time

*Just as lotions and fragrance give sensual delight,
a sweet friendship refreshes the soul.*
PROVERBS 27:9 MSG

Jesus' disciples were more than just apprentices learning the ins and outs of faith. They were also Jesus' closest friends. They walked together, talked together, ate together, and prayed together. When Jesus knew His time on earth was short, He turned to them for support. Follow Jesus' example. No matter how busy you get, make time for the friends God brings into your life. They may be God's answers to prayers you're praying today.

Lord, thank You for the friends You have put into my life. Forgive me for often being too busy to make time to nurture my relationships. My friends refresh my soul and draw me closer to You. With them I get a glimpse into the divine fellowship of eternity. Amen.

Day 112
Beyond the Horizon

Always continue to fear the LORD. You will be rewarded
for this; your hope will not be disappointed.
PROVERBS 23:17–18 NLT

Have you ever traversed a long, winding road, unable to see your final destination? Perhaps you were surprised by twists and turns along the way or jarred by unexpected potholes. But you were confident that if you stayed on *that* road, you would eventually reach your destination. Likewise, God has mapped out our futures. The end of the road may disappear beyond the horizon, but we are assured that our destination will not be disappointing.

Dear Lord, You see the end from the beginning, and
nothing surprises You. Thank You for the confidence
that gives us when we trust in You. When we can't see
how the next hour is going to turn out—much less the
next day—we hope in You. In grateful trust, amen.

Day 113

You Are Free

So if the Son sets you free, you are truly free.
JOHN 8:36 NLT

"Jesus paid it all, all to Him I owe." You've heard that old hymn, right? Here's the thing: Jesus says you owe Him nothing. He says there are no charges against you. You're free to go. He paid it all for you. The Bible says that He casts your sins into the depths of the sea and remembers them no more.

Freedom in Christ means that you don't have to carry around a heavy load of guilt. He wants you to walk in your freedom. He paid dearly for it. Jesus won't load you up with rules and guilt. That's religion—not Jesus. Dependence on Jesus brings rest and freedom (see Matthew 11:28–30).

Jesus, help me to believe the truth that I am free.
I'm so thankful for the price You paid for that freedom.

Day 114

Wholesome and Everlasting

*I chose you. I appointed you to go and produce
lasting fruit, so that the Father will give you
whatever you ask for, using my name.*
JOHN 15:16 NLT

Pick up a banana at the supermarket, forget about it for a few days, and voilà! You wind up with a black, mushy mess. There's only one kind of fruit that doesn't spoil. That's spiritual fruit. Because of your faith in God, you can trust He's growing wholesome, everlasting fruit in you. You can nurture this fruit—helping it grow to maturity—by watering it frequently with God's words. Read the Bible, and then watch what God produces in your life.

*Dear Father, thank You for Your Word. It is the soil
which nourishes my faith, the light that strengthens my
faith, the water that renews me when I am dry and
tired. Forgive me for the times I have ignored Your
life-giving Word. Help me to dig deeply into it. Amen.*

Day 115

You Are Free from Condemnation

So now there is no condemnation for those who belong to Christ Jesus. And because you belong to him, the power of the life-giving Spirit has freed you from the power of sin that leads to death.

ROMANS 8:1–2 NLT

Check out these verses from The Message: "With the arrival of Jesus, the Messiah, that fateful dilemma is resolved. Those who enter into Christ's being-here-for-us no longer have to live under a continuous, low-lying black cloud. A new power is in operation. The Spirit of life in Christ, like a strong wind, has magnificently cleared the air, freeing you from a fated lifetime of brutal tyranny at the hands of sin and death."

No more black clouds. No more condemnation. No more guilt and shame. Instead, Jesus has cleared the air. You are free.

Jesus, I'm so thankful for all You've done for me.

Day 116

One Step at a Time

*Because Jesus was raised from the dead, we've been
given a brand-new life and have everything to live for,
including a future in heaven—and the future starts now!*
1 PETER 1:3–4 MSG

The future isn't something that's waiting off in the distance. It's right here, right now. Every breath you take brings you into that future, one step at a time. And the future that awaits you is good. Faith changes the course of your future as surely as it changes the landscape of your heart. God is preparing a home for you that will never be torn down, a place where your questions will be answered and your longings fulfilled.

*Lord, we long for heaven; we long to worship You as
we were created to do; we long for the close fellowship
for which we were intended; we long for pleasant days
without end. Help us now to see heaven more clearly
as well as the blessings of these days on earth. Amen.*

Day 117

You Are Hidden
with Christ in God

Set your minds on things above, not on earthly things.
For you died, and your life is now hidden with Christ
in God. When Christ, who is your life, appears,
then you also will appear with him in glory.
COLOSSIANS 3:2–4 NIV

Your safety and security come from Christ alone. That's not just the hope of heaven someday. Jesus came so that you could know your security now. When you set your mind on things above, God gives you an eternal perspective of your life. You see people as eternal and things as temporary. The eternal becomes much more important right now than the material. You are covered, secure, made new, and completely safe in Christ. Now and forever. Lift your head.

Jesus, I accept the fact that I'm hidden with You.
You cover me and make me new. You give me
confidence to live this life with an eternal perspective.

Day 118

Never Alone

*I am convinced that nothing can ever separate
us from God's love. Neither death nor life, neither
angels nor demons, neither our fears for today
nor our worries about tomorrow—not even the
powers of hell can separate us from God's love.*
Romans 8:38 NLT

I read a poll that said being alone is one of women's worst fears. When we experience loss, we sometimes feel that we're struggling all alone, that others around us can't possibly comprehend the scope of our fears, our worries, our pain. But the Bible says we're not alone, that *nothing* can separate us from our heavenly Father. He is right there beside us, loving us, offering His companionship when we have none.

*Dear Father, it is hard for me to feel Your presence
sometimes, but I trust Your Word. It says I am not
alone; it says Your Spirit is with me; it says Jesus is
always interceding for me. Forgive me for doubting,
and help me to walk by faith, not by sight. Amen.*

Day 119

God Will Finish What He Started in You

I am convinced and confident of this very thing, that He who has begun a good work in you will [continue to] perfect and complete it until the day of Christ Jesus [the time of His return].
PHILIPPIANS 1:6 AMP

Take hope! Don't be discouraged by where other people are on their journey. Stop judging yourself so harshly, and stop judging others too. That's for God to do. God will do what He's promised to do. He hasn't forgotten you. He doesn't just move you along on the journey, drop you off, and let you go. Nope. He has eternal plans and purpose for your life. He sees you. He will finish what He started in you. He is actively at work in you right now. Trust Him.

Thank You for this reminder, Lord God. You are good, and You see me. I put my trust in You alone.

Day 120

Big-Hearted

*I am praying that you will put into action the generosity
that comes from your faith as you understand and
experience all the good things we have in Christ.*
<small>PHILEMON 1:6 NLT</small>

When you choose to follow Christ, your faith opens the flood-gates of countless good gifts. You receive things like forgiveness, salvation, a future home in heaven, and God's own Spirit living inside you. God's generosity is incomparable. It can also be motivational. When someone is incredibly generous with you, it inspires you to share more generously with others. Whether it's your time, your finances, your home—or things like forgiveness, grace, or love—follow God's example. Be big-hearted and open-handed.

*Lord, sometimes I think I have nothing to give,
but then I remember the gifts You have given me:
forgiveness, salvation, hope. Those are incomparable
riches that I have the privilege of sharing with
others. They cost nothing, but they are more
valuable than anything money could buy. Amen.*

Day 121

Your Heart Is God's Home

*Then Judas (not Judas Iscariot) said, "But, Lord,
why do you intend to show yourself to us and not to
the world?" Jesus replied, "Anyone who loves me will
obey my teaching. My Father will love them, and we
will come to them and make our home with them."*
John 14:22–23 NIV

The disciples couldn't figure out why Jesus didn't come as a
high king to take over the world. But Jesus has always been
about individual relationship. He came as a personal God. He
cares about every little detail of you. He wants you to know His
heart that way too. He promises that He will make His home in
you as you follow Him. As you pray today, think about the God
of heaven coming and making your heart His home. What does
that look like? How does it feel? What does it change for you?

Make my heart Your home, Lord.

Day 122

Can You Hear Me Now?

*But as for me, I watch in hope for the LORD, I wait
for God my Savior; my God will hear me.*
MICAH 7:7 NIV

If there's anything more frustrating than waiting for someone
who never shows, it's trying to talk to those who aren't listening.
It's as if they have plugged their ears and nothing penetrates.
Mothers are well acquainted with this exercise in futility, as are
wives, daughters, and sisters. But the Bible tells us that God
hears us when we talk to Him. He shows up when we wait for
Him. He will not disappoint us.

*Dear God, we are thankful for Your Spirit which both
shows us our sin and gives us the strength to change.
Help us never to be guilty of ignoring Your voice—or
the voices of those around us. Give us ears to listen,
because we know You are the God who hears. Amen.*

Day 123

You Are a Temple of the Holy Spirit

Do you not know that your bodies are temples of the Holy Spirit, who is in you, whom you have received from God? You are not your own; you were bought at a price. Therefore honor God with your bodies.

1 CORINTHIANS 6:19–20 NIV

When you commit your life to Christ, His Spirit miraculously comes to live inside you, and you become a temple of the Holy Spirit. A temple is any place or object in which God dwells, as is the body of a Christian (1 Corinthians 6:19). Isn't that an amazing thing to read in a dictionary? So if your very own body is a place where God Himself dwells, how does that change how you view yourself?

Lord, forgive me for how I've viewed my body in the past. I commit to viewing myself and my body with new eyes.

Day 124

Utmost Love and Care

Have you ever come on anything quite like this
extravagant generosity of God, this deep, deep wisdom?
It's way over our heads. We'll never figure it out.
ROMANS 11:33 MSG

Consider what it would be like to own everything. Absolutely *everything*. Even the universe is under your control. In this scenario, it seems like it would be easy to be generous. After all, you have so much. But God treasures every speck of His creation—especially His children. Entrusting us with free will and with the job of caring for this planet was a risky venture. Honor God's generosity by treating His gifts with the utmost love and care.

Lord, it's easy to be careless with things that aren't
ours—to trample, to litter, to waste. Help us see this
beautiful planet as a gift You've given us to steward as
though it belonged to us alone. And help us see other
people as gifts to nurture and protect as well. Amen.

Day 125
Good Meals

*He satisfies the longing soul, and fills
the hungry soul with goodness.*
PSALM 107:9 NKJV

When you're preparing a holiday meal, chances are you don't settle for "good enough." You rely on your favorite dishes—ones that look good, taste good, and are good for you. God feeds your soul similar spiritual fare. Like a good cook who consistently turns out good meals, our good God consistently bestows good gifts. Sometimes they're delectable delights; other times they're much needed vegetables. You can trust in God's goodness to serve up exactly what you need.

Lord, we don't always like what You serve us: chocolate cake, yes, but celery, maybe not. Help us see that all the things You give us are for our good, which makes them good, regardless of their taste in the moment. When we can't see what we need, You always can. Amen.

Day 126

A New Tomorrow

Rahab the prostitute. . .Joshua spared. . .because she hid
the messengers whom Joshua sent to spy out Jericho.
JOSHUA 6:25 NASB

Rahab was the unlikeliest of heroes: a prostitute who sold her body in the darkest shadows. Yet she was the very person God chose to fulfill His prophecy. How astoundingly freeing! Especially for those of us ashamed of our past or who feel we've strayed too far from God to ever be used by Him. God loved Rahab for who she was—not what she did. Rahab is proof that God can and will use anyone for His higher purposes. *Anyone.* Even you and me.

> *Lord, You have formed me in an ordinary sort of way,*
> *without x-ray vision or the ability to fly. But I can do*
> *Your will, because You have given me Your strength.*
> *And that is more than enough. Thank You for being*
> *willing to use me—a sinner—just like Rahab. Amen.*

Day 127
By Grace Alone

God saved you by his grace when you believed.
And you can't take credit for this; it is a gift from God.
EPHESIANS 2:8 NLT

It's humbling to accept a favor from someone, especially when you know it's one you can never repay. But that's what grace is: a gift so big you don't deserve it and can never repay it. All God asks is a tiny, mustard-seed-sized grain of faith in return. When you tell God, "I believe," His grace wipes away everything that once came between you and Him. Lies. Anger. Betrayal. Pride. Selfishness. They're history. . .by God's grace alone.

Dear Lord, we always feel like we have to do something
to earn the grace we've been given: serve more, read
the Bible more, witness more, pray more. But this verse
reminds us that grace is a gift for which no repayment is
necessary—or even possible. Thank You, Father! Amen.

Day 128

You Are Seated with Christ in the Heavenlies

And He raised us up together with Him [when we believed], and seated us with Him in the heavenly places, [because we are] in Christ Jesus.

Ephesians 2:6 amp

We all need Jesus because we've sinned so much. God could have just given up on the whole lot of us. But here's what Ephesians 2:4–6 (msg) says: "Instead, immense in mercy and with an incredible love, he embraced us. He took our sin-dead lives and made us alive in Christ. He did all this on his own, with no help from us! Then he picked us up and set us down in highest heaven in company with Jesus, our Messiah." The Bible says that this is our *current* position, not a "when you die and go to heaven" position. This is powerful stuff!

Jesus, I believe what You say is true. Help me to live my daily life like I believe it.

Day 129
Unfailing Love

On the outside it often looks like things are falling
apart on us, on the inside, where God is making new
life, not a day goes by without his unfolding grace.
2 CORINTHIANS 4:16 MSG

When you first chose to believe in God, His grace wiped away every past digression you'd ever made from the life He designed for you to lead. But His grace doesn't stop there. Every day, it's at work. You may be God's daughter, but you're still growing. There will be times you'll stumble—times you'll look to yourself first instead of to God. God's grace continues to cleanse you and draw you closer to Him, reassuring you of His unfailing love.

Dear Father, give us Your eyes to see the new life
unfolding around us, even when it looks like things
are falling apart. If You are in us, You are at work
in us. Help us to look to You more each day and to
follow closely behind You, walking in faith. Amen.

Day 130
Pure and Unspoiled

And everyone who has this hope set on Him
purifies himself, just as He is pure.
1 JOHN 3:3 NASB

Don't you just love taking the first scoop of ice cream from a
fresh half gallon? There's something about the smooth surface
of unspoiled purity that satisfies the soul. It's the same with
new jars of peanut butter, freshly fallen snow, or stretches of
pristine, early-morning beach sand. God looks at us that way—
unblemished, pure and unspoiled—through our faith and hope
in Him. Allow that thought to bring a smile to your face today.

Dear Father, while we were yet sinners, Christ died
for us. Thank You for that great gift of imputed
righteousness so that we too can be washed clean and
white as snow. Help us to live with that hope fixed
unwaveringly in our hearts. We love You. Amen.

Day 131

You Are Born of God

*Everyone who believes that Jesus is the Christ has
been born of God, and everyone who loves the
Father loves whoever has been born of him.*

1 JOHN 5:1 ESV

The Bible has much to say about Jesus' followers being born
of God. Take a look:

- Yet to all who did receive him, to those who believed in
 his name, he gave the right to become children of God—
 children born not of natural descent, nor of human deci-
 sion or a husband's will, but born of God. (John 1:12–13
 NIV)

- We know that anyone born of God does not continue to
 sin; the One who was born of God keeps them safe, and
 the evil one cannot harm them. (1 John 5:18 NIV)

*I'm so thankful that You made me
Your child, Lord God. I will follow You.*

Day 132
The Right Direction

Each morning let me learn more about your
love because I trust you. I come to you in
prayer, asking for your guidance.
PSALM 143:8 CEV

If you're navigating a road trip, just owning a map isn't going to get you to your destination. You need to compare where you are on the map with where you want to go, follow road signs, and evaluate your progress. God's Spirit works in much the same way. Each morning, ask Him to help you head in the right direction. Then, throughout the day, evaluate where you are and who you believe God wants you to be.

Dear Lord, often I wake up in the morning and the
first things I think about are what's on my to-do list
and how quickly I can get to the coffeepot. Forgive
me for thinking of my own agenda and comfort and
forgetting You. I desire to put You first. Amen.

Day 133

Surprised by Happiness

*You will come to know God even better. His glorious
power will make you patient and strong enough to
endure anything, and you will be truly happy.*
COLOSSIANS 1:10–11 CEV

Faith is a journey. Like any journey, it's a mixed bag of experiences. You can celebrate grand vistas, then slog through bogs of mud—all in the same day. Though happiness is often dependent on circumstances, when your journey's guided by faith you can find yourself feeling happy at the most unexpected moments. Perhaps God brings a Bible verse to mind that encourages you. Maybe you see Him at work in a "coincidence." Where will God surprise you with happiness today?

*God, open up our eyes so that we can see Your mighty,
loving hand at work in our lives—from the smallest
coincidence to the biggest miracle. . .even in the
ho-hum days where nothing much seems to happen.
You are at work in every circumstance. Amen.*

Day 134

Cherished Desire

*God our Father loves us. He treats us with
undeserved grace and has given us eternal
comfort and a wonderful hope.*

2 Thessalonians 2:16 cev

Webster's definition of *hope* is "to desire with expectation of obtainment or fulfillment." In other words, it's yearning for something wonderful you *expect* to occur. Our hope in Christ is not just yearning for something wonderful, as in "I hope for a sunny beach day." It's a deep trust with roots that extend from the beginning of time to the infinite future. Our hope is not just the anticipation of heaven but also the expectation of a fulfilling life walking beside our Creator and best friend.

*Lord, I am saved both now and in the future. That
is a mystery too great for me. I praise You because
You are too great for me, yet You love me so much
You would die for me. That love is mine now
and forever. In Jesus' precious name, amen.*

Day 135

God Is Always Working Everything Out

*And we know that in all things God works
for the good of those who love him, who have
been called according to his purpose.*
ROMANS 8:28 NIV

The Bible talks a lot about being blessed and having joy. When Jesus talked about having joy, He was talking about us having a deep understanding that He is with us and making everything right—no matter what. That means that even if things seem all wrong, you can still have joy. Why? Because of this promise from God right here in Romans: "In all things God works for the good of those who love him." You can bank on it. Even during hard times. He sees everything about us and is at work for our good.

*Jesus, help me to trust that You're
working everything out for my good.*

Day 136

More to Love

*Make me as happy as you did when you
saved me; make me want to obey!*
PSALM 51:12 CEV

Relationships grow and change. If you're in a marriage relationship, recall that honeymoon phase. Loving each other seemed easy and exciting, pretty much all the time. Then comes everyday life. Apathy creeps in. The happiness you first felt may seem to fade. The same thing can happen with God. Don't settle for apathy when there's always more to love and discover about God (and people!). Ask God to help you look at those you love—including Him—with fresh eyes.

*Lord, when I first married my husband, I longed to
do things that made him happy. I looked for ways
to please him. Have I ever been that way with You?
Help me bring back the joy I had when You first
saved me, by seeking to please You. Amen.*

Day 137

You Are Sealed by God

Now it is God who makes both us and you stand
firm in Christ. He anointed us, set his seal of
ownership on us, and put his Spirit in our hearts
as a deposit, guaranteeing what is to come.

2 CORINTHIANS 1:21–22 NIV

You have been sealed by God, and nothing and no one can snatch you out of His hands. John 10:28–29 (NIV) says, "I give them eternal life, and they shall never perish; no one will snatch them out of my hand. My Father, who has given them to me, is greater than all; no one can snatch them out of my Father's hand."

Say this out loud: "I am anointed. I am sealed by God.
His Spirit is alive in my heart. I can stand firm in Christ."
Lord, help me believe that all Your words are true.

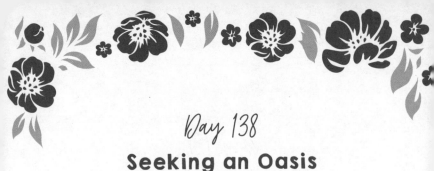

Day 138

Seeking an Oasis

He turns a wilderness into a pool of water,
and a dry land into springs of water.
<small>PSALM 107:35 NASB</small>

The wilderness of Israel is truly a barren wasteland—nothing but rocks and parched sand stretching as far as the distant horizon. The life-and-death contrast between stark desert and pools of oasis water is startling.

Our lives can feel parched too. Colorless. Devoid of life. But God has the power to transform desert lives into gurgling, spring-of-water lives. Ask Him to bubble up springs of hope within you today.

Dear Lord, You know how I am feeling today. Something
I longed for has been taken away, and even though the
trees outside are bright with autumn color, I am dull
and gray inside. Please come in, Lord. Please revive
my hope and my spirit as only You can. Amen.

Day 139

Safe in His Arms

My health may fail, and my spirit may grow weak,
but God remains the strength of my
heart; he is mine forever.
Psalm 73:26 NLT

Our bodies are miraculous works of art. But they don't last forever. When you're ill or in pain, God is near. As any parent who's ever loved a child knows, He aches *with* you as well as *for* you. When the hope of healing seems distant, if you've run out of words to pray, picture yourself safe in His arms. Wait quietly, expectantly. Listen for His words of comfort. Rest in His promised peace. Hold on to Him for strength.

> *Dear Lord, it is so hard to watch children in pain and*
> *know that you cannot do anything for them except*
> *hold them, brush the hair off their hot foreheads, and*
> *pray. But You, Lord, are a Father who can heal, and*
> *You will—either now or in eternity. In praise, amen.*

Day 140

Anytime, Anywhere

*Get up and pray for help all through the
night. Pour out your feelings to the Lord,
as you would pour water out of a jug.*

LAMENTATIONS 2:19 CEV

There's probably no more common prayer than the word *help*.
Even those who aren't aware they're calling out to the living God
cry out for help in times of despair, fear, or pain. But you know
God is near. You know He hears. In faith, you believe He will
help. Regardless of your circumstances—big or small—don't
wait until you come to the end of your rope to pray. Call out
to Him anytime, anywhere.

*Dear Lord, I'm calling out to You now. I am besieged
by my sins, consumed by my worries, harassed by
busyness. I need You to come into this storm, into my
little sinking boat, and calm the seas. Help, Lord. I know
You are answering; I know You are with me. Amen.*

Day 141

More Than Conquerors

No, in all these things we are more than conquerors through him who loved us. For I am convinced that neither death nor life, neither angels nor demons, neither the present nor the future, nor any powers, neither height nor depth, nor anything else in all creation, will be able to separate us from the love of God that is in Christ Jesus our Lord.

ROMANS 8:37–39 NIV

The truth of God's Word is staggering to those of us who believe. If Christians lived this truth out every day, if we walked in the courage that Christ says is ours, it would change everything. It *can* change everything. It *will* change everything for you—if you believe it.

Jesus, I want to walk in Your truth. Help me to live this out every day. Forgive me for my unbelief at times. Give me the courage to trust Your Word.

Day 142

Name above All Names

O God, we give glory to you all day
long and constantly praise your name.
PSALM 44:8 NLT

So what has God done that deserves our everlasting praise?
His descriptive names tell the story: a friend that sticks closer
than a brother (Proverbs 18:24), altogether lovely (Song of
Solomon 5:16), the rock that is higher than I (Psalm 61:2),
my strength and my song (Isaiah 12:2), the lifter of my head
(Psalm 3:3), shade from the heat (Isaiah 25:4). His very name
fills us with hope!

God, there are not enough words in all the languages on
earth to praise You adequately. Nothing we can say or
sing or shout would ever express just who You are or what
You have done for us. Father, Savior, Counselor—You
are worthy of all our praises, now and eternally. Amen.

Day 143

More Reasons to Hope

Let us hold unswervingly to the hope we
profess, for he who promised is faithful.
HEBREWS 10:23 NIV

What do you hope for? *Really* hope for? Perhaps it's security, significance, or a relationship that will never let you down. Hopes like these are fulfilled solely through faith. Read God's track record as recorded in the Bible. He keeps His promises in areas like these time and again. It's true that it takes faith to place your hope in someone you can't see. But you're building your own track record with God. Day by day, you'll discover more reasons to hope in Him.

Lord, I need to know: Is my hope really in You alone?
In my secret heart, am I holding on to something else as
my salvation? Search my heart, Lord; know my anxious
thoughts. And lead me in the way everlasting. . .which
is my only real hope in this life and the next. Amen.

Day 144

You've Been Transferred

*For he has rescued us from the kingdom of darkness
and transferred us into the Kingdom of his dear Son,
who purchased our freedom and forgave our sins.*
COLOSSIANS 1:13–14 NLT

When a transfer happens at a company, you move all your belongings and yourself to a new office, sometimes a new state. You may even have a new role. This is exactly what Christ intends for you too. All of you has been transferred from darkness into the kingdom of light. You don't live and work in the dark anymore. You can't even go back to that office. You've been transferred out, and the doors have been locked. Allow the truth of this transfer to transform you. You're in a new state now. Let it give you courage.

*Lord, I'm so thankful for this unimaginable transfer.
Help me walk in the light as You are in the light.*

Day 145

Hope of Heaven

What you hope for is kept safe for you in heaven.
You first heard about this hope when you believed
the true message, which is the good news.
COLOSSIANS 1:5 CEV

Faith gives us many reasons for hope. A home in heaven is just one of them. But what exactly are you hoping for? The Bible tells us we'll receive a new body, one that never grows ill or old. Tears will be a thing of the past. We'll be in the company of angels, other believers, and God Himself. Scripture tells us words cannot fully describe what we'll find there. That's a hope worth holding on to.

Lord, we're likely to be surprised about a lot of things
when we get to heaven. Questions of doctrine or theology
will be incorporated into worship; we won't need to argue
and guess anymore—we will know as we have always
been known. Help us live now with that in mind. Amen.

Day 146

You Are a Light in the Darkness

You are the light of [Christ to] the world. A city set on a hill cannot be hidden; nor does anyone light a lamp and put it under a basket, but on a lampstand, and it gives light to all who are in the house. Let your light shine before men in such a way that they may see your good deeds and moral excellence, and [recognize and honor and] glorify your Father who is in heaven.

MATTHEW 5:14–16 AMP

God has put you in certain circumstances and areas to be His light in the darkness. Don't be intimidated when things look dark. You are right where you are for a season and a reason. Can you take your eyes off your current gloomy circumstances and look up? Ask Jesus to brighten your light in the darkness.

Jesus, please give me the courage to shine Your light in the dark.

Day 147

The Ultimate Gardener

*In simple humility, let our gardener, God, landscape you
with the Word, making a salvation-garden of your life.*
JAMES 1:21 MSG

Some women have a bona fide green thumb. They take a seemingly dead stick and nurture it into a verdant piece of paradise. Consider how ridiculous it would be for that once-sickly stick to brag to his foliage friends about the great turnaround he'd accomplished in his own life. Obviously, all credit goes to the gardener. God is the ultimate gardener. His focus is tending His children. Humbly allow Him to have His way in helping your faith grow.

> *Dear Lord, thank You for the soil of faith in which You
> have planted me and the life-giving water You shower
> upon me when I read Your Word. I am humbled by
> Your tender care. Help me to accept all You do—both
> pruning and fertilizing—with thanksgiving. Amen.*

Day 148
First Love

*But you must stay deeply rooted and firm in
your faith. You must not give up the hope you
received when you heard the good news.*
COLOSSIANS 1:23 CEV

Do you remember the day you turned your life over to Christ?
Can you recall the flood of joy and hope that coursed through
your veins? Ah, the wonder of first love. Like romantic love that
deepens and broadens with passing years, our relationship with
Jesus evolves into a river of faith that endures the test of time.

*Dear Lord, we praise You for faith, which is not
something we could conjure up ourselves; it is a gift of
Your Spirit. We praise You that faith is strong enough
to live on. It is our present help and our future hope.
Help us cling to it, for better or worse. Amen.*

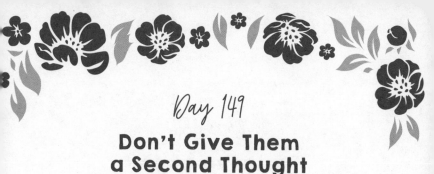

Day 149

Don't Give Them a Second Thought

*Be strong and courageous, do not be afraid or tremble
in dread before them, for it is the Lord your God who
goes with you. He will not fail you or abandon you.*
DEUTERONOMY 31:6 AMP

Remember our focus verse? "Be strong. Take courage. Don't be intimidated. . . . GOD, your God, is striding ahead of you. He's right there with you. He won't let you down; he won't leave you" (Deuteronomy 31:6 MSG). Spend some time in God's Word, and you'll see that He has lots to say about the intimidation or fear of man.

First John 4:4 (AMP) says, "Little children (believers, dear ones), you are of God and you belong to Him and have [already] overcome them [the agents of the antichrist]; because He who is in you is greater than he (Satan) who is in the world [of sinful mankind]."

*Lord, release me from the fear
of man as I turn my gaze on You.*

Day 150

Reserve of Joy

*Though you have not seen him, you love him; and even
though you do not see him now, you believe in him
and are filled with an inexpressible and glorious joy.*

1 PETER 1:8 NIV

In the Declaration of Independence, American citizens are guaranteed the right to the "pursuit of happiness." That's probably because happiness is something that must constantly be pursued. Even if you catch it, you can't hold on to it. Joy, on the other hand, is a gift of dependence. The more you depend on God, the deeper your well of joy. Ask God to show you how to draw on that reserve of joy in any and every circumstance.

*Lord, forgive us for the days when we stomp around like
the weight of the world is on our shoulders, like everything
depends on us. That is a lie we tell ourselves when we
forget Your sovereignty. The weight of the world is on Your
shoulders. Everything depends on You. In praise, amen.*

Day 151

A Transformed Mind

*Don't copy the behavior and customs of this world, but
let God transform you into a new person by changing
the way you think. Then you will learn to know God's
will for you, which is good and pleasing and perfect.*

ROMANS 12:2 NLT

Your thoughts matter to God. Did you know that it's possible
to direct your thoughts? If you notice that you're thinking
negatively, then at that very moment, purposefully switch your
thoughts to focus on something positive. Over time you can
create a healthy habit of positive thinking. As believers, we
want to align our thoughts with the truth of God's Word. He
has so much wisdom to share with us about how to think and
how to relate to others. He does not want us to be intimidated
by toxic people or the toxic thinking of our own selves at times.

*Lord, highlight any wrong thinking in me.
Show me how to align my thoughts with Yours.*

Day 152

Unlikely Ways

When troubles of any kind come your way, consider it an
opportunity for great joy. For you know that when your
faith is tested, your endurance has a chance to grow.
JAMES 1:2–3 NLT

Trouble and *joy* may seem an unlikely pair, something akin to sardines and chocolate syrup. But God seems to prefer the unlikely. He chose a speech-impaired Moses as His spokesman and simple fishermen as missionaries. These choices brought challenges. But when faith is pushed to its limits, God works in wonderfully unlikely ways. Regard troubles as opportunities instead of obstacles. As you rely on God, His glory will shine through you—and unexpected joy will be your reward.

Dear Father, we don't welcome trouble and suffering;
we don't welcome the testing of our faith. Help us to
reorient our thinking to line up with Your Word. Help us
consider troubles as opportunities for joy and the growth
of our faith, which is worth more than gold. Amen.

Day 153

Feel the Love

Long before he laid down earth's foundations,
he had us in mind, had settled on us as the focus
of his love, to be made whole and holy by his love.
EPHESIANS 1:4 MSG

Need a boost of hope today? Read this passage aloud, inserting your name for each *us*. Wow! Doesn't that bring home the message of God's incredible, extravagant, customized love for you? I am the *focus* of His love, and I bask in the hope of healing, wholeness, and holiness His individualized attention brings. You too, dear sister, are His focus. Allow yourself to feel the love today.

Dear Father, long before You laid down earth's
foundations, You had me in mind, had settled on me
as the focus of Your love, to be made whole and holy
by Your love. I stand amazed at this love. All I can say
is thank You, thank You. In grateful praise, amen.

Day 154

As You Think, You Are

For as he thinks in his heart, so is he
[in behavior—one who manipulates].
PROVERBS 23:7 AMP

Guarding your thought life is vital. Your thoughts affect everything, and over time they will eventually become concrete substances in your brain.

Second Corinthians 10:5 tells us to take our thoughts captive and make them obey Jesus. So how do you do that? When you have a bad thought about yourself or others, take it directly to Jesus. When you are feeling intimidated in any way, pray and ask Jesus to take that thought away and fill you with His truth. Then focus on something good. Ask Jesus to fill your mind with something that comes from Him.

Jesus, set my mind on things above.

Day 155

Benevolent Balance

*What does the LORD require of you? To act justly and
to love mercy and to walk humbly with your God.*
MICAH 6:8 NIV

God is both merciful and just. His justice demands that restitution be made for the wrongs we've done. His mercy allows those wrongs to be paid for in full when we put our faith in Jesus' death and resurrection. One way of thanking God for this benevolent balance is by treating others fairly, mercifully, and with humility. When we "do the right thing," we love others the "right" way—a way that reflects our heavenly Father's own character.

> *Lord, forgive me for the times I have been short with
> waitresses, cashiers, DMV employees, telemarketers,
> and others. Show me how to act with mercy and
> humility toward other people, even when they are
> not acting the way I think they should. Only Your
> Spirit living in me can accomplish that. Amen.*

Day 156

A Steadfast Mind

*You will keep in perfect peace those whose minds
are steadfast, because they trust in you.*
Isaiah 26:3 NIV

The Amplified Bible gives us more clarification on this verse: "You will keep in perfect and constant peace the one whose mind is steadfast [that is, committed and focused on You—in both inclination and character], because he trusts and takes refuge in You [with hope and confident expectation]."

When we focus our thoughts on Jesus, we can go into any circumstance or relationship with confidence that comes from setting our minds on things above. Will worrying about what other people think of you keep you in perfect peace? Nope, never. The exact opposite even. But the choice is yours. You have free will over your thinking.

*Lord Jesus, help me choose to take my thoughts
captive. Please give me a steadfast mind.*

Day 157

Words and Actions

Everything depends on having faith in God, so that God's promise is assured by his gift of undeserved grace.
ROMANS 4:16 CEV

A wise mother schools her children in the ways of kindness not only with her words but also through her actions. God works the same way. Through the words of the Bible, God encourages His children to treat each other with respect, generosity, and consideration. But it's God's personal kindnesses to you that encourage your faith. Today, consider the many ways God has been kind to you just this week. What will your response be?

Dear Lord, You have been so kind to me this week. You have fed, clothed, and housed me. You have kept me free from sickness. You have calmed my anxiety. You have given me fellowship with other believers and opportunities to praise Your name. You are so good! Amen.

Day 158

Changing Direction

*Finally, brothers and sisters, whatever is true, whatever
is noble, whatever is right, whatever is pure, whatever
is lovely, whatever is admirable—if anything is
excellent or praiseworthy—think about such things.*
PHILIPPIANS 4:8 NIV

It's easy to get off track and think about things we shouldn't—even when we're praying! We start off thinking about something good, and then we easily get distracted by other thoughts and people. The next time you find yourself thinking about something that isn't right, ask Jesus to step into your thoughts and change them! Just speak His name and ask Him to come to your rescue. The name of Jesus has all power in heaven and earth (Philippians 2:10), and just speaking His name can change the direction of your thoughts.

*Jesus, Your name is powerful. I pray You
will step in and change my thoughts to
be pure and true when I'm distracted.*

Day 159

Forever and Always

Never will I leave you; never will I forsake you.
HEBREWS 13:5 NIV

Unconditional love. We all yearn for it—from our parents, our spouses, our children, our friends. Love *not* based on our performance or accomplishments, but on who we are deep down beneath the fluff. God promises unconditional love to those who honor Him. We don't need to worry about disappointing Him when He gets to know us better—He knows us already. Better than we know ourselves. And He loves us anyway, forever and always.

God, You are the only one who actually loves us
unconditionally—with no strings attached, no clauses
or codicils. We can do nothing to earn Your love,
and You promise never to take that love away. Help
us to love others the way You love us. Amen.

Day 160

Incredible Potential

*As obedient children, let yourselves be pulled
into a way of life shaped by God's life, a life
energetic and blazing with holiness.*

1 PETER 1:15 MSG

Your life has incredible potential. It's filled with opportunities to love, laugh, learn, and make a positive difference in this world. Faith turns every opportunity into an invitation: *Will you choose to live this moment in a way that honors God?* What you do with your life matters. But, ultimately, who you become is more important than what you accomplish. As your faith grows, your heart more resembles God's own. That's when you recognize where your true potential lies.

*Lord, we have our own ideas about what our lives should
look like and what we should accomplish. Give us faith
to let our lives and goals be conformed to Yours. Help us
see that we will lose nothing! Remind us daily that You
will use people who give their lives wholly to You. Amen.*

Day 161
Relax

*For the Holy Spirit will teach you
at that time what you should say.*
LUKE 12:12 NIV

The next time you find yourself in an intimidating situation, relax. *That sounds great,* you say, *but how? You don't know how my heart starts pounding and the sweat starts pouring when I get nervous in public.* Here's the thing: if Christ is alive in you, then He is at work. If He wants you to do or say something in a certain situation, you can trust Him to let you know. And you don't have to worry about it ahead of time. This might take some practice. Whenever you're headed into a stressful situation, be present with God the entire time. Invite Him to speak to you. Tell Him how you're feeling. Then let it rest in His hands. Trust Him.

*Lord, this kind of thing takes a lot more trust
than I feel I have. Please fill me with more faith.*

Day 162
Never Alone

Jesus often withdrew to lonely places and prayed.
LUKE 5:16 NIV

Loneliness can make you feel like you're on a deserted island surrounded by a sea of people—yet no one notices you're there. But there is someone who notices. Someone who will never leave you. Someone who won't forget you or ignore you, no matter what you've done. You may be lonely, but you're never alone. Find a place of solace in the silence through prayer. Loneliness may be the perfect lifeline to draw you closer to God, the one whose love will never fail.

Lord, loneliness can turn us inward to gaze at ourselves and our problems, or it can turn us outward—to You. We ask for Your Spirit to continually remind us of Your presence and our need for You. If we love You, we are never truly alone. You are here. Amen.

Day 163

Astounding Rescue

*Then I remember something that fills me with hope.
The LORD's kindness never fails! If he had not
been merciful, we would have been destroyed.*
LAMENTATIONS 3:21–22 CEV

With our hectic lifestyles, pausing to remember the past isn't something we do very often. But perhaps we should. Then, when doubts assault our faith, fears threaten to devour us, and disaster hovers like a dark cloud, we'll remember God's past loving-kindnesses. Hope will triumph over despair. Keeping a prayer journal is a wonderful way to chronicle answered prayer. We'll always remember the times when God's merciful hands rescued us in astounding ways.

*Dear Lord, help me pause and remember and speak of
Your faithfulness. Let me mark these instances in my
journal, just as the Israelites did when they left piles of
stones as reminders to themselves and their children.
Teach me to look back in thankfulness. Amen.*

Day 164

Let Love Shine

What if I had faith that moved mountains?
I would be nothing, unless I loved others.
1 CORINTHIANS 13:2 CEV

What mountain are you facing today? Perhaps it's the reconciliation of a relationship. Or maybe it's just that pile of laundry you've neglected. Whatever it is, it would be nice to simply "pray it away." But faith isn't a gift God gives to make life easier. Faith is God's classroom, in which we learn how to become more loving—more like God Himself. Ask God to let love shine through in everything you do—even sorting kids' socks.

Dear Father, I ask for Your love to shine through in
everything I do—from the mundane chores of everyday
life to the once-in-a-lifetime moments. I can't muster
up love; it comes only from You. Holy Spirit, fill me
so full of love that it spills out to others. Amen.

Day 165
Steady Me

Provide me with the insight that comes only from your Word. Give my request your personal attention, rescue me on the terms of your promise. . . . Every order you've given is right. Put your hand out and steady me since I've chosen to live by your counsel.
PSALM 119:170–173 MSG

The Bible tells us that God gives us wisdom and insight and that He gives it freely without finding fault (James 1:5–7). The only requirement is that you trust Him. Believe that God's will is best and that He will lead and guide you in making decisions that align with His purposes.

God wants you to hear His voice and know His will for you. He has promised in His Word that if you seek Him, you *will* find Him if you seek with all your heart (Jeremiah 29:13).

Lord, help me come to You for wisdom and insight. Steady my heart and mind in You alone.

Day 166

Aware of the Details

*By faith we understand that the universe was
formed at God's command, so that what is seen
was not made out of what was visible.*
HEBREWS 11:3 NIV

It takes faith and science to appreciate the wonders of nature.
Science describes the improbability of generations of butterflies
migrating thousands of miles to specific destinations they've
never experienced firsthand or the impossibly delicate balance
of our orbiting solar system. Faith assures us God not only
understands miracles like these but sets them in motion. Surely
a God who cares for the tiniest detail of nature is aware—and
at work—in every detail of your life.

*Lord, when I look at the stars, I am reminded
how small I am. . .but also how much You love
me. You didn't send Your Son to die for the stars
or butterflies; You sent Him to die for me. I am of
infinite value to You. Thank You, Lord. Amen.*

Day 167

Keeping Us in Stitches

*The secret things belong to the L*ORD *our God.*
DEUTERONOMY 29:29 NIV

Have you ever noticed the messy underside of a needlepoint picture? Ugly knots, loose threads, and clashing colors appear random, without pattern. Yet if you turn it over, an exquisite intricate design is revealed, each stitch blending to create a beautiful finished picture. Such is the fabric of our lives. The knots and loose threads may not make sense to us, but the master designer has a plan. The secret design *belongs* to Him.

Lord, sometimes the only way we can continue putting
one foot in front of the other when doubts and disasters
assail us is because we know that You are in control.
You have a purpose and a plan, and someday we will
stand in awe of the design You have created. Amen.

Day 168
A New Nature

*Since you have heard about Jesus and have learned
the truth that comes from him, throw off your old sinful
nature and your former way of life, which is corrupted
by lust and deception. Instead, let the Spirit renew
your thoughts and attitudes. Put on your new nature,
created to be like God—truly righteous and holy.*
EPHESIANS 4:21–24 NLT

People-pleasing, gossip, taking on the responsibility of others, caving to manipulation or manipulating others, dark thoughts—all these are part of the old nature, the old self. But when Jesus comes alive in you, His Spirit empowers you to throw off the old nature and take your thoughts captive to the power and light of Christ. As you find yourself going back to old, destructive thought patterns, stop yourself in the moment and say the name of Jesus.

Jesus, I need Your help and power to change my thoughts.

Day 169

A Written Invitation

Ever since the world was created, people
have seen the earth and sky. Through everything
God made, they can clearly see his invisible
qualities—his eternal power and divine nature.

ROMANS 1:20 NLT

God's story is written in more places than the Bible. It's written in the glory of the setting sun, the faithfulness of the ocean tides, the symphony of a thunderstorm, and the detail of a dragonfly's wing. It's written in every cell of you. Take time to "read" more about who God is as described through His creation. Contemplate His organizational skills, creative genius, and love of diversity. Consider nature God's written invitation to worship and wonder.

Dear Lord, help us to be always pointing up—directing
the gaze of others to You and Your amazing work in
creation and salvation. But so often we are just pointing
at ourselves. Please forgive us for our small vision,
and instead tune our hearts to praise You. Amen.

Day 170
A New Start

But there is another power within me that is at war with my mind. This power makes me a slave to the sin that is still within me. Oh, what a miserable person I am! Who will free me from this life that is dominated by sin and death? Thank God! The answer is in Jesus Christ our Lord.
ROMANS 7:23–25 NLT

You find yourself slipping into old patterns, thinking negatively about yourself or others, feeling down—what then? Romans 7 echoes this same kind of humanness. The answer is the start of the very next chapter: "So now there is no condemnation for those who belong to Christ Jesus. And because you belong to him, the power of the life-giving Spirit has freed you from the power of sin that leads to death" (Romans 8:1–2 NLT). You can start again.

Jesus, thank You for the truth that I am not condemned. Please give me the power to start again.

Day 171

Permission to Mourn

When I heard this, I sat down on the ground and cried. Then for several days, I mourned; I went without eating to show my sorrow, and I prayed.
NEHEMIAH 1:4 CEV

Bad news. When it arrives, what's your reaction? Do you scream? Fall apart? Run away?

Nehemiah's response to bad news is a model for us. First, he vented his sorrow. It's okay to cry and mourn. Christians suffer pain like everyone else—only, we know the source of inner healing. Disguising our struggle doesn't make us look more spiritual. . .just less *real*. Like Nehemiah, our next step is to turn to the only true source of help and comfort.

Dear God, when You were on earth, You wept. It isn't wrong to cry; it doesn't mean we don't trust You. It just means we're human: meant for perfection but living as sinners in a fallen world. We praise You for knowing us, for being one of us, for being the God of all comfort. Amen.

Day 172

Always Hope

Remember, our Lord's patience
gives people time to be saved.
2 PETER 3:15 NLT

We're thankful for God's patience with us. He consistently honors us with time to grow, room to fail, and an endless supply of mercy and love. But we aren't the only ones who benefit from His patience; He extends it to everyone, including those we feel are slow learners or those we consider hopeless cases. In God's eyes, and in God's timing, there's always hope. Ask God to help you extend to others what He so graciously extends to you.

Dear Father, sometimes we think certain people will never
be saved. We can't see Your sovereign plan from our
vantage point here on earth, but we know You long for all
to come to a saving knowledge of You. Give us patience
to wait; You are working on those stony hearts. Amen.

Day 173
Heavenly Things

Therefore if you have been raised with Christ [to a new life, sharing in His resurrection from the dead], keep seeking the things that are above, where Christ is, seated at the right hand of God. Set your mind and keep focused habitually on the things above [the heavenly things], not on things that are on the earth [which have only temporal value].
COLOSSIANS 3:1–2 AMP

Intimidating situations and people come at us often. You will get lots of practice with this one. In that moment when anxious feelings come, ask Jesus to give you a calm and a peace that comes from focusing on Him. As the situation unfolds or the intimidating person talks, invite Jesus to give you an eternal perspective of the person or situation. Be on the lookout for what He wants to show you.

Jesus, help me to keep my eyes on You and listen as You show me eternal perspectives.

Day 174

Permanent Peace

*Since we have been made right in God's sight
by faith, we have peace with God because of
what Jesus Christ our Lord has done for us.*
ROMANS 5:1 NLT

When world leaders sign a peace treaty, they pledge to keep the terms of an agreement. They aren't agreeing to like it—or each other. When you put your faith in Christ's sacrifice on your behalf, you make peace with God. God pledges to forgive your past grievances and even future mistakes. But the peace between you and God is more than an agreement. It's the rebirth of a relationship. This peace is permanent, based on unconditional love, not legality.

*Lord, when I put my trust in You, I stepped into Your
loving hands. Now and forever, You are holding me.
You promise never to put me down. And when You
look at me, You see me through the blood of Jesus. . .
as righteous. Thank You for that amazing grace. Amen.*

Day 175
Pebbles

*I will give you a new heart and put a new spirit
within you; and I will remove the heart of stone
from your flesh and give you a heart of flesh.*
EZEKIEL 36:26 NASB

So many things can harden our hearts: overwhelming loss,
shattered dreams, even scar tissue from broken hearts, dis-
illusionment, and disappointment. To avoid pain, we simply
turn off feelings. Our hearts become petrified rock—heavy,
cold, and rigid. But God can crack our hearts of stone from
the inside out and replace that miserable pile of pebbles with
soft, feeling hearts of flesh. The amazing result is a brand-new,
hope-filled spirit.

*Dear Lord, only You can do the work in us of turning
stone to flesh. You give; You put; You remove; You change.
We praise You that You don't leave us with these hard,
dead hearts but give us life through Your Spirit. We
praise You for working in us, even when it hurts. Amen.*

Day 176

Happy Heart, Joyful Mind

A happy heart is good medicine and a joyful mind
causes healing, but a broken spirit dries up the bones.
PROVERBS 17:22 AMP

Stress is hard on a body, physically and mentally. Extended and unrelenting stress can cause heart problems and even death. God does not want us to carry all that on our shoulders. It's too much. But life is hard, and traumatic things do happen. Does God want you just to sweep your troubles under the rug and paste on a happy, fake face? Surely not. Jesus invites you to come to Him with everything. As you give Him permission to heal your hurts and heartaches, He supernaturally gives you rest and peace. As you linger in His very presence, He fills you with His joy that brings healing.

Jesus, I bring You my heartaches and my worries.
I want Your healing presence in my life.

Day 177

A Perfect Complement

I am leaving you with a gift—peace of mind and heart. And the peace I give is a gift the world cannot give. So don't be troubled or afraid.

JOHN 14:27 NLT

When attending a going-away party, it's customary to give a gift to the one who's going away. Jesus turned this concept on its head, as He so often did with the status quo. At the Last Supper, the day before He died, Jesus gave all His followers a gift—peace. When you choose to follow Jesus, you receive this gift. You'll find it fits your life perfectly, complementing any and every circumstance.

Lord, You ask nothing for Yourself but our hearts—and You give us everything else in return. Thank You for Your perfect peace. It is our hope and comfort in this crazy world. When worry and fear try to grab hold of us, teach us how to cling to Your peace. Amen.

The Greatest Command

*And Jesus replied to him, "You shall love the
Lord your God with all your heart, and with
all your soul, and with all your mind."*
MATTHEW 22:37 AMP

Reading this verse in other paraphrases can help us think about
this scripture in new ways:

- Jesus said, "'Love the Lord your God with all your pas-
 sion and prayer and intelligence.' This is the most import-
 ant, the first on any list." (MSG)
- Jesus answered him, "'Love the Lord your God with every
 passion of your heart, with all the energy of your being,
 and with every thought that is within you.'" (TPT)

What comes to mind when you think of loving God with
your passion, prayer, intelligence, energy, and every thought?
How can this help you when facing intimidating people or
circumstances?

*Lord, I want to follow the greatest command and love
You with every part of my being, in every situation.*

Day 179

Lean on Him

Consider him who endured such opposition from sinners,
so that you will not grow weary and lose heart.
HEBREWS 12:3 NIV

Jesus literally went through hell for you. He suffered the pain of rejection and betrayal. He endured physical agony. He gave His life out of love for you. When you face what seems unendurable, hold on to Jesus. Cry out to Him for help and hope. Pray throughout the day, picturing Him by your side, holding you up when your own strength fails. Express your love for Him by leaning on Him. He's near to help you persevere.

Lord, when I imagine You by my side holding me up, that's not just wishful thinking; You are actually there. You promised Your disciples that You would always be with them, and that promise is for me too. Thank You, Lord. I am holding on to You. Amen.

Day 180

Do a Little Dance

*Then Miriam the prophet, Aaron's sister, took
a tambourine and led all the women as they
played their tambourines and danced.*
EXODUS 15:20 NLT

Can you imagine the enormous celebration that broke out among the children of Israel when God miraculously saved them from Pharaoh's army at the Red Sea? Even dignified prophetess Miriam grabbed her tambourine and cut loose with her girlfriends. Despite adverse circumstances, she heard God's music and did His dance. Isn't that our goal today? To hear God's music above the world's cacophony and do His dance as we recognize everyday miracles in our lives?

*Lord, loosen my feet to praise You with this body You
have given me! I may look awkward or foolish or
strange, but I just want to praise You with everything
I have. You are worthy of songs, dances, and shouts!
All praise to our amazing, saving God. Amen.*

Day 181

Words and Thoughts

*May these words of my mouth and this
meditation of my heart be pleasing in your
sight, LORD, my Rock and my Redeemer.*
PSALM 19:14 NIV

Your thoughts and your words are very important to God. Take a look at what the Bible says: "A good person produces good things from the treasury of a good heart, and an evil person produces evil things from the treasury of an evil heart. What you say flows from what is in your heart" (Luke 6:45 NLT).

Basically, what goes in is what comes out. If the things you are taking in, such as entertainment choices, social media posts, and conversations, are honoring to God, you are storing good things in your heart. And that's what will come out. The opposite is also true. What are you filling your heart and mind with?

*Lord, I want to honor You with what
I'm taking into my mind and heart.*

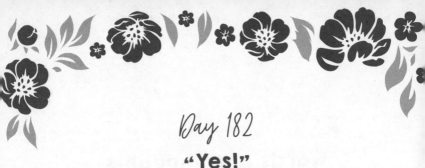

Day 182
"Yes!"

We pray for God's power to help you do all the good things
you hope to do and your faith makes you want to do.
2 THESSALONIANS 1:11 CEV

Faith gives you the desire—and power—to do things you may have never even dreamed of attempting before. Serving meals to the homeless. Leading a Bible study. Praying for an ailing coworker. Sharing your personal story aloud in church. Forgiving someone who's betrayed you. The more you grow in your faith, the more God will stretch your idea of who you are—and what you can do. Through God's power, you can confidently say, "Yes!" to doing anything He asks.

Dear Father, You give us the faith to step beyond what is
comfortable and easy into a life of miraculous service.
Please continue to strengthen us and increase our
faith so that what we desire to do tomorrow is greater
and better than what we desire to do today. Amen.

Day 183

The Mind of Christ

Who ever knows what you're thinking and planning except
you yourself? The same with God—except that he not
only knows what he's thinking, but he lets us in on it.
1 CORINTHIANS 2:11–12 MSG

The New Living Translation paraphrases verse 12 like this:
"And we have received God's Spirit (not the world's spirit), so
we can know the wonderful things God has freely given us."

Verse 16 in The Message says, "Isaiah's question, 'Is there
anyone around who knows God's Spirit, anyone who knows
what he is doing?' has been answered: Christ knows, and we
have Christ's Spirit."

Why is all of this so extremely important? Because without
God's Spirit alive in us, we couldn't possibly know or follow
the ways of Christ. But because He is. . .we can!

Lord, I'm so thankful that You've given me Your Spirit.
Without Him, I would never be able to go against the
strong pull of the world to follow You and know Your ways.

Day 184

As the Tide Turns

He will not falter or be discouraged till
he establishes justice on earth. In his
teaching the islands will put their hope.
ISAIAH 42:4 NIV

Change. Besides our unalterable Lord, it's the only thing constant in this world. Yet the only person who likes change is a baby with a wet diaper. Isaiah prophesied that the Almighty will one day create positive change on earth. Like the tides that clean beach debris after a storm, positive change washes away the old and refreshes with the new. In this we hope.

Dearest Lord, You are never discouraged. You never
falter. Your plans always come to pass. Nothing
is outside Your control. We praise You for who
You are—infinite, incomprehensible, immutable,
all-wise. Your justice is coming. In that day—and
today, as we hope in You—we will shout AMEN!

Day 185

A Clean Life in a Dirty World

How can a young person live a clean life? By carefully reading the map of your Word. I'm single-minded in pursuit of you; don't let me miss the road signs you've posted. I've banked your promises in the vault of my heart so I won't sin myself bankrupt.

PSALM 119:9–10 MSG

Our culture is sexualized and full of darkness. It can be so hard to remain pure in thought and action with impurity constantly staring us right in the face. Even when we're not looking for it, it comes and seeks us out! The Bible gives us hope that we, no matter how young or old, can live a pure life in the midst of the battle. When we store up the promises of God by reading and knowing the truth from His Word, we make deposits in our hearts that won't fail us.

Jesus, purify my mind and my heart with Your Word.

Day 186

Power Source

We are like clay jars in which this treasure is stored.
The real power comes from God and not from us.
2 CORINTHIANS 4:7 CEV

What happens if your blow-dryer won't blow? First, you check out the power source. Without power, a blow-dryer may look useful, but it's really nothing more than a plastic knickknack. It's God's power working through you that allows you to accomplish more than you can on your own. Staying connected with God through prayer, obedience, reading the Bible, and loving others well will keep His power flowing freely into your life—and out into the world.

> *Lord, I long to be useful to You. In my pride, I think I*
> *can do things that will please You. Remind me that it*
> *is only Your Spirit working in me that can accomplish*
> *anything, and that because of Jesus' sacrifice on the*
> *cross, I already please You. In thanksgiving, amen.*

Day 187
Letting Go

*Do not remember the former things, or ponder the things
of the past. Listen carefully, I am about to do a new thing,
now it will spring forth; will you not be aware of it? I will
even put a road in the wilderness, rivers in the desert.*
ISAIAH 43:18–19 AMP

Like all of us, you probably have some things in your past you'd
really like to forget. But heated conversations and failures often
replay themselves in your mind. Jesus doesn't want you to keep
carrying those burdens around. You can't fix everything, and
you certainly can't fix other people. But you can fix your mind
on Christ: "Forgetting what is behind and straining toward what
is ahead, I press on toward the goal to win the prize for which
God has called me heavenward in Christ Jesus" (Philippians
3:13–14 NIV).

*Jesus, please help me let go of
past failures and press on in faith.*

Day 188

Because of You

When your faith remains strong through many trials,
it will bring you much praise and glory and honor on
the day when Jesus Christ is revealed to the whole world.

1 PETER 1:7 NLT

The thought of God praising you may be a new one. But when Jesus returns, what you've done and overcome because of your faith will be visible to all. But it's not the accolades of others that make this worth anticipating. It's the chance to see God smile—and know it's because of you. In this life, you may feel your efforts go unnoticed. Rejoice in knowing God sees and praises everything you do because of your faith in Him.

These days are long, Lord. We know You are tarrying
so that many more souls would be saved, but it is hard
to wait. We pray that when You do come, we would be
found faithful—working, serving, loving, proclaiming.
We long to hear You say on that day, "Well done." Amen.

Day 189
Up Is the Only Out

Let them lie face down in the dust,
for there may be hope at last.
LAMENTATIONS 3:29 NLT

The Old Testament custom for grieving people was to lie prostrate and cover themselves with ashes. Perhaps the thought was that when you're wallowing in the dust, at least you can't descend any further. There's an element of hope in knowing that, from there, there's only one way to go—up. If a recent loss has you sprawled in the dust, know that God doesn't waste pain in our lives. He will use it for some redeeming purpose.

Dear Father, we thank You for putting us in a position
where our only hope is in You. Thank You for the stones
under our knees and the dust in our nostrils. Thank You
for being right there with us. Thank You for Your voice
in our darkness and Your hand reaching out. Amen.

Day 190

Easy to Recognize

Be joyful in hope, patient in affliction, faithful in prayer.
ROMANS 12:12 NIV

How do you build a relationship with a friend? You spend time together. You talk about everything, openly sharing your hearts. Prayer is simply talking to your best friend. True, it's harder to understand God's reply than it is to read a friend's text or access her phone message. But the more frequently you pray, the easier it is to recognize God's voice. So keep talking; God's listening. With time, you'll learn how to listen in return.

Dear Lord, I know You are listening, but I don't often feel it. I long to know You intimately, but it's hard to continue when I don't hear You answer back. Please help me persevere in prayer, reaching out to You who will be there until my faith becomes sight. Amen.

Day 191
Answers

This is GOD's Message, the God who made earth,
made it livable and lasting, known everywhere
as GOD: "Call to me and I will answer you. I'll
tell you marvelous and wondrous things that
you could never figure out on your own."
JEREMIAH 33:3 MSG

When you talk to God, He wants to have a real conversation with you. Praying is not about sending a wish list to heaven. It's telling God how you feel about certain things and then listening for His answers. God answers us in lots of ways. He can speak to us through just about anything (one time He even spoke through a donkey! Look up the story here: Numbers 22:28–30). He loves to speak through His Word, through worship songs, through the love of another Jesus follower, through His creation—God's ways are limitless. The next time you pray, sit and listen for God to answer. What is He telling you?

Help me to hear and understand Your answers, Lord.

Day 192

In Line with the Truth

Everything you ask for in prayer
will be yours, if you only have faith.
MARK 11:24 CEV

Faith keeps our prayers in line with the truth behind what we say we believe. If we believe God loves us, believe Jesus is who He said He was, believe God has a plan for our lives, believe He's good, wise, and just—then our prayers will reflect these beliefs. They'll be in line with God's will—with what God desires for our life. These are the kinds of prayers God assures us He'll answer, in His time and His way.

> *Dear Father, we humbly acknowledge that the prayer*
> *offered in faith—the one You promise to answer—is*
> *the prayer offered in line with Your will. That means*
> *we might have to change what or how we are asking.*
> *Help us to remember who You are as we pray. Amen.*

Day 193

Getting to Know You

For the law never made anything perfect.
But now we have confidence in a better hope,
through which we draw near to God.
HEBREWS 7:19 NLT

Following Old Testament law used to be considered the way to achieve righteousness, but obeying rules just doesn't work for fallible humans. We mess up. We fail miserably. Then Jesus came and provided a better way to draw near to God. He bridged the gap by offering us a personal relationship rather than rules. Together we laugh, cry, love, grieve, rejoice. . . We get to *know* our Papa God through our personal relationship with Him.

Dear Father, we are in awe of the fact that You
want us to know You, that You care about having
a personal relationship with Your creatures. That
both humbles and amazes us. Help us to prize
that relationship above everything else and to
throw off anything that hinders it. Amen.

Day 194

Blazing with Holiness

*So roll up your sleeves, get your head in the game,
be totally ready to receive the gift that's coming when
Jesus arrives. Don't lazily slip back into those old
grooves of evil, doing just what you feel like doing.
You didn't know any better then; you do now. As
obedient children, let yourselves be pulled into a way
of life shaped by God's life, a life energetic and blazing
with holiness. God said, "I am holy; you be holy."*
1 PETER 1:13–16 MSG

The Christian life is not a set of rules you must follow to please God. Again, that's religion. The difference in following Jesus is that His Spirit is alive in you. That's where the power comes from to live the Christian life! You don't have to muster strength on your own. Allow Jesus to shape your life the way He wants to. Holiness is only possible through His Spirit alive and at work in you.

Jesus, thank You for Your work in me!

Day 195

Always Welcome

*Because of Christ and our faith in him, we can now
come boldly and confidently into God's presence.*
EPHESIANS 3:12 NLT

Being in the presence of someone you've wronged isn't a comfortable place to be. Even after apologies have been offered and restitution made, a feeling of shame and unworthiness often lingers. This isn't the case in our relationship with God. When we set things straight through faith, all that lingers is God's love. Draw close to God in prayer. Never be afraid to enter His presence. You're always welcome, just as you are.

*Dear Lord, we can come before You boldly because
You don't forgive like people do. Our sins often
stain and scar others permanently. But You are
holy, and Your forgiveness is as wide and deep as
the ocean; it erases our sin completely, as though
it had never been. Praise the Savior! Amen.*

Day 196

The Courage to Be Real

Love from the center of who you are; don't fake it. Run for dear life from evil; hold on for dear life to good. Be good friends who love deeply; practice playing second fiddle.

ROMANS 12:9–10 MSG

Fake news, fake people, fake eyelashes. . .It's easy to check out when nothing around you seems real. But Jesus asks us to press in—to be *in* the world but not *of* it (John 17:14–19). This means we don't subscribe to the spirit of the age or the popularity of the day. Instead, we offer up the timeless love and light of Jesus to everyone we come in contact with. We were sent into this world not to condemn people and separate ourselves from them but to love them and offer hope in the darkness. Keep on loving. Keep on speaking truth. Keep on being yourself.

Jesus, help me love others with Your love. Help me be real so that others can see the real You in me.

Day 197

Superwoman Isn't Home

But we will devote ourselves to prayer
and to the ministry of the word.
ACTS 6:4 NASB

As busy women, we've found out the hard way that we can't do everything. Heaven knows we've tried, but the truth has found us out: Superwoman is a myth. So we must make priorities and focus on the most important. Prayer and God's Word should be our faith priorities. If we only do as much as we *can* do, then God will take over and do what only He can do. He's got our backs, girls!

Dear Father, so often I find time to do everything except
pray and read Your Word. Forgive me. Help me to see
the idols and sins that keep me from running to You
daily. Help me to root out even good things if they
are keeping me from You. In Jesus' name, amen.

Day 198

Spirit-Filled Life

*When God lives and breathes in you (and he does,
as surely as he did in Jesus), you are delivered
from that dead life. With his Spirit living in
you, your body will be as alive as Christ's!*

ROMANS 8:11 MSG

Imagine what your life would be like if you believed this in every moment—God Himself is living and breathing in you! That's exactly what the Bible tells us is true, yet many Christians don't live like it. They think we're sent here to trudge through mud and try to endure this life until we get to heaven. That is far from the truth. Jesus died and rose again to save you from sin and evil. He came to heal and restore you. Don't get trapped into believing anything else!

*Jesus, I want to live out the truth I see
in Your Word! You are alive in me!*

Day 199

Saved and Secure

You have faith in God, whose power will protect
you until the last day. Then he will save you,
just as he has always planned to do.

1 PETER 1:5 CEV

Life can seem pretty precarious. The evening news fills our heads and hearts with stories of disaster and demise. In light of it all, our bodies appear so fragile. But the Bible tells us God has numbered our days. He's planned the day of our birth and the day we'll die. Nothing, and no one, can alter those plans. Like your future, your faith is under God's sovereign care. Within the power of His protection, you're saved and secure.

Dear Father, help me remember these verses when worry
chips away at my faith. Help me turn up the volume
of Your voice and Your promises until they drown out
the voices of disaster and demise. You are in control.
You hold us. We are saved and secure. Amen.

Day 200

God, Your God,
Is Striding Ahead of You

*It is the LORD who goes before you. He will
be with you; he will not leave you or forsake
you. Do not fear or be dismayed.*
DEUTERONOMY 31:8 ESV

Think about the last time you felt fear—deep, alarming fear.
What caused it? A noise in the night? A child in danger? Bring
to mind a memory of fear that you've had. Why was it so trou-
bling to you? As you begin your prayer time, ask Jesus what He
wants you to know about this memory. Where was He when
you were so worried? Sit with this memory in your mind and
begin to pray. Ask Jesus for His truth in the situation. Write
down what He tells you.

*Jesus, I bring You my memories and my fears.
Please increase my faith as I begin to understand
that You will never leave me nor forsake me.*

Day 201

Inexplicable Strength

The joy of the LORD is your refuge.
NEHEMIAH 8:10 NASB

Joy is not based on the circumstances around us. It is not synonymous with happiness. God promised believers His deep, abiding joy—*not* fleeting happiness, which is here today, gone tomorrow. The joy of the Lord rises above external situations and supernaturally overshadows everything else to become our inexplicable, internal strength.

Dear Father, help us to understand and remember that happiness is fleeting but joy is at the center of the Trinity—and spreads outward to us. Thank You for being the source of all the joy in the universe. We praise You that Your joy is stronger than anything—even death. Amen.

Day 202

A God Who Fights,
a Dad Who Carries

The LORD your God is going ahead of you. He will
fight for you, just as you saw him do in Egypt.
DEUTERONOMY 1:30 NLT

The Message paraphrases verses 30–31 this way: "GOD, your
God, is leading the way; he's fighting for you. You saw with
your own eyes what he did for you in Egypt; you saw what
he did in the wilderness, how GOD, your God, carried you as
a father carries his child, carried you the whole way until you
arrived here."

Any good father, if his beloved child is in danger, will fight
to free her from an enemy and carry her to safety. Our God
does this too. Have you needed a champion in your life? Can
you picture Jesus fighting for you and carrying you in His arms?

Thank You for being a good, good Father to me!

Day 203

Shelter from the Storm

*GOD's a safe-house for the battered, a sanctuary
during bad times. The moment you arrive,
you relax; you're never sorry you knocked.*
PSALM 9:9–10 MSG

Your shoes are caked in mud. Your hair clings like a damp rag, and you smell a bit like a wet schnauzer. But the rain doesn't let up. All you want is a warm, dry spot—a shelter from the storm. The Bible says you'll face all kinds of storms in this life. But God's your safe place, regardless of what's raging all around you. He's with you in every storm, offering protection and peace. Don't hesitate to draw near.

Lord, thank You for being our strong tower, our fortress in times of war. We sure need that right now; the world gets crazier with every passing day, and even the ground under our feet is unstable. We are knocking, Lord. Thank You for always being home to answer when we call. Amen.

Day 204

Hand of Blessing

You go before me and follow me. You place
your hand of blessing on my head.
PSALM 139:5 NLT

God promises that nothing can separate us from His love when He has made us His children (Romans 8:38–39). Nothing you could do could make God love you more or less than He does right now. Mistakes never change how much God loves you. His Word tells us that He goes before us and follows us. His hand of blessing is on us. Does that make you feel secure and fully loved? God is a good Dad who always gets things right. You may have your own parent wounds that need healing. Jesus wants to heal them and bless you. Let Him parent you well, no matter how old you are. We're all in need of a parent's blessing.

Thank You for loving me more than I can imagine,
Father. Thank You for Your healing and blessing.

Day 205

Far Beyond the Basics

God will generously provide all you need.
Then you will always have everything you
need and plenty left over to share with others.
2 CORINTHIANS 9:8 NLT

Need is an easy word to use—and abuse. "I need new shoes to go with this outfit." "I need chocolate, right here, right now!" "I need some respect!" When God says He'll provide what we need, it's always on His terms, not ours. He provides everything we need to do everything He's asked us to do. Yet our loving God goes far beyond supplying the basics. He surprises us by filling to overflowing needs we never even knew we had.

Lord, forgive me for complaining that You aren't listening
if You don't respond the way I think You should when
I pray. You're actually telling me I don't need what
I've asked for. You are God; You know exactly what I
need and what I don't. Help me rest in that. Amen.

Day 206

He Is Able

The prospect of the righteous is joy.
PROVERBS 10:28 NIV

Living joyfully isn't denying reality. The righteous do not receive a "Get Out of Pain Free" card when they place their trust in Christ. We all have hurts in our lives. Some we think we cannot possibly endure. But even in the midst of our darkest times, our heavenly Father is able to reach in with gentle fingers to touch us and infuse us with joy that defies explanation. Impossible? Perhaps by the world's standards. Yet He is *able*.

Lord, what You ask seems impossible, but we ask You to make the impossible possible in our lives. We ask for Your joy in our trials. Only Your Spirit can give us that. We look to You, just as Jesus looked through the cross to the joy set before Him. Amen.

Day 207

God's Hand

For I am the LORD your God who takes hold of your right hand and says to you, Do not fear; I will help you.
ISAIAH 41:13 NIV

If there is a scripture you need to have handy in times of trouble, this is it! Post it on your fridge and commit it to memory so that the Spirit of God can bring it to mind when you need to hear it most. Psalm 139:7–10 tells us that no matter where we go, His hand will guide us and hold us. Heading to the emergency room? Repeat Isaiah 41:13, and remember that God is holding your hand. Afraid of the future? Put your trust in the God who loves you and has great plans for you. Facing a problem that you cannot possibly bear? Take hold of God's mighty hand and believe that He will help you.

*Father God, help me not to fear.
Take hold of my hand and guide me.*

Day 208

Wholeness

Jesus declared, "I am the bread of life. Whoever comes to me will never go hungry, and whoever believes in me will never be thirsty."

JOHN 6:35 NIV

When we talk about provision, our physical needs first come to mind: food, water, shelter, and the like. But we have spiritual needs that are just as essential as the air we breathe. We thirst for God's forgiveness and hunger for His love. Those who haven't yet put their faith in God often try filling this need with power, possessions, or relationships. But only a relationship with God can fill this void. Only faith provides wholeness to a broken world.

Lord, all we really need is salvation. If we die without it, we are lost for eternity; if we have it, then nothing in this life can shake our eternal security. It's Jesus; He's all we need. Thank You for providing all we need in this life and the next. Amen.

Day 209
Made Like Us

For this reason he had to be made like them,
fully human in every way, in order that he might
become a merciful and faithful high priest in service to
God, and that he might make atonement for the sins of
the people. Because he himself suffered when he was
tempted, he is able to help those who are being tempted.
HEBREWS 2:17–18 NIV

God chose to come to earth in human form to be made like us. To understand what it's like to be human. To be able to fully take our place and remove our sins. Because He was fully human while being fully God, He can help. He can comfort. Our God is not one who wants to remain as a distant high king, out of touch with the commoners. He wants a very personal relationship with each one of us. He lowered Himself to our level so that we could have personal and continual access to Him.

Thank You for becoming one of us, Jesus.
Thank You for Your comfort.

Day 210

Forever Joy

We don't look at the troubles we can see now. . . .
For the things we see now will soon be gone,
but the things we cannot see will last forever.
2 CORINTHIANS 4:18 NLT

A painter's first brush strokes look like random blobs—no discernable shape, substance, or clue as to what the completed painting will be. But in time, the skilled artist brings order to perceived chaos. Initial confusion is forgotten in joyful admiration of the finished masterpiece.

We often can't see past the blobs of trouble on our life canvases. We must trust that the artist has a masterpiece underway. And there will be great joy in its completion.

Dear Lord, we ask for faith to persevere when we can't
see the picture You are creating with the circumstances of
our lives. When we doubt, help us to look at the glorious
world around us as evidence of Your artistry and to
remember that we too are Your handiwork. Amen.

Day 211

Through the Wilderness

To Him who led His people through the wilderness,
for His lovingkindness endures forever.
PSALM 136:16 AMP

Victor Hugo said, "Have courage for the great sorrows of life and patience for the small ones. And when you have finished your daily task, go to sleep in peace. God is awake." It may feel like you are stuck in the wilderness right now. But God is with you. Even when it seems like you can't see Him or hear Him or feel His presence. Dry and weary seasons cannot last forever. Take courage and trust that this season will pass. What does God want to show you in the midst of the wilderness? Ask Him to give you a vision for the season of time you're in right now.

Jesus, help me to have courage and patience
during this season. Increase my trust in
You. Show me that You're with me.

Day 212

Set in Stone

*We humans keep brainstorming options
and plans, but GOD's purpose prevails.*
PROVERBS 19:21 MSG

When people mention "the best-laid plans," they're usually be-moaning how the unexpected derailed what once seemed like a sure thing. God's the master of the unexpected. That doesn't mean planning is a bad thing. It helps us use time, money, and resources in a more efficient way. But the only plans that are set in stone are God's own. Make sure your plans are in line with God's purposes. That's the wisest thing you can do to assure success.

> *Lord, we think we can say that a certain thing
> will happen at a certain time and in a certain
> way. We think our purposes will prevail.
> Thank You for the way You thwart those plans
> over and over again so we learn—slowly and
> painfully—who is truly in control. Amen.*

Day 213

Beyond Your Imagination

God is able to do much more than we ask or
think through His power working in us.
EPHESIANS 3:20 NLV

The New International Version says that God can do "immeasurably more" than what you could imagine. When God's power is at work within you, the possibilities are beyond your imagination. Whatever problem you are facing right now—big or small—God cares. As you pray and think about it, don't put God in a box, assuming that there's no way out or that there is only one right answer. He is always going before you. And His response just might be beyond your understanding and your wildest imagination. Things aren't always what they seem. If you feel disappointed in God's answers to your prayers, look outside the box. God is always, always working everything out for your good.

Lord, help me to trust that You are working
everything out in the best possible way.

Day 214
Restart

You're my place of quiet retreat;
I wait for your Word to renew me.
PSALM 119:114 MSG

If your computer has a glitch, it's helpful to refresh the page or reboot the whole program by pushing RESTART. God helps us refresh, reboot, and restart by renewing us through His Spirit. When you're in need of refreshment—even if you've already spent time with God that day, reading the Bible, singing His praises, or praying—take time to sit quietly in God's presence. Push RESTART. Wait patiently, and expectantly, for a word from the one you love.

Lord, thank You that it is never too late to begin again. It wasn't too late for the thief on the cross, and it isn't too late for me today. Already I need a do-over, and I ask for Your Spirit to refresh me. I know You are eager to speak. Amen.

Day 215

Perfect Love

*Love never gives up, never loses faith, is always
hopeful, and endures through every circumstance.*
1 CORINTHIANS 13:7 NLT

We have relationships in three directions: upward (with God),
outward (with others), and inward (with ourselves). We are
bound to be disappointed at one time or another by the latter
two. Because of human frailty, we will inevitably experience
failure by others and even ourselves. Our imperfect love will
be strained to the breaking point. But our Creator will never
fail us—His perfect love truly *never* gives up on us.

*Father, thank You for Your amazing love. Forgive us
for how we have failed to love You and others; forgive
us for expecting others to love us perfectly when
only You can do that. Help us remain willing to love
and be loved, despite how difficult it is. Amen.*

Day 216

Hearing from Jesus

Long ago God spoke many times and in many ways
to our ancestors through the prophets. And now in
these final days, he has spoken to us through his Son.
God promised everything to the Son as an inheritance,
and through the Son he created the universe.
HEBREWS 1:1–2 NLT

When you look at Jesus, you get a clear picture of God. And
He can speak directly to you. You may not hear an out-loud
voice, but Jesus can speak to your heart as He answers your
prayers and talks to you. And He will make Himself clear to you
if you seek Him. In Jeremiah 29:13 (NIV), God says, "You will
seek me and find me when you seek me with all your heart."
Ask Jesus to speak clearly to you today. What is He saying?

Jesus, help me to be able to hear from
You and get to know Your voice.

Day 217
Time to Rest

It is useless for you to work so hard from early morning until late at night, anxiously working for food to eat; for God gives rest to his loved ones.

PSALM 127:2 NLT

For three years, Jesus *devoted* his life to spreading the good news about God's love. This was an incredibly important job, one with eternal consequences. But even Jesus took time to rest. Although He dined with friends, taught, preached, and performed miracles, many times he left spiritually hungry crowds behind to spend time alone with His heavenly Father. You have many important roles to fill in this life. Rest is one of God's gifts that can empower you to accomplish what He's given you to do.

Lord, You know me. You know that I start every day with a to-do list and how much pleasure I get in checking things off. You know how "unproductive" activities irritate me. But You give rest to Your loved ones. Thank You for this timely reminder to stop. Amen.

Day 218

He Knows You by Name

*The Lord said to Moses, "I will do what you
have said. For you have found favor in My
eyes, and I have known you by name."*
EXODUS 33:17 NLV

The God who made all creation knows your name and everything about you. He loves you just the way you are, and He set you on earth at this exact time in history for a purpose. God wants you to know Him. He wants you to know how much He loves you and tenderly cares for you.

God promises to go before you and to be with you wherever you go. Have you told God how much you love Him today? He is waiting to hear from you.

*Lord, it's sometimes hard to believe that You
know everything about me and love me anyway.
But Your Word tells me it's true. I love You,
God. Thanks for being so close to me.*

Day 219

Gold Crowns

The LORD rewards people who are faithful and live right.
1 SAMUEL 26:23 CEV

Exactly how God rewards His children is a bit of a mystery. The Bible tells us we'll receive gold crowns in heaven, which we'll promptly cast at Jesus' feet to honor Him. But the Bible also talks about rewards in this life. Our rewards may be delivered in tangible ways, such as through success or financial gain. But our reward may also be a more intangible treasure, such as contentment and joy. Treasures like these will never tarnish or grow old.

Lord, I ask You to fill my storehouse with the things that can never be stolen or destroyed. Love, joy, peace, patience, kindness, and self-control are rewards given by the Spirit—crowns that are a part of us and can never be taken away. Thank You for these imperishable rewards. Amen.

Day 220

Lighthouse Love

For God, who said, "Light shall shine out of darkness," is the One who has shone in our hearts.

2 CORINTHIANS 4:6 NASB

Have you heard the story of the lighthouse keeper's daughter who kept faithful vigil for her sailor? Every night she watched as the light's beam pierced the blackness and sliced through raging storms, driven by relentless hope that her lover would return to her on the morning's tide. God loves us like that. He's our light in the darkness, guiding, beckoning, and filling our hearts with hope. He never tires. He never stops.

Almighty God, You are our lighthouse—the light shining in the darkness, faithfully warning of the rocks and waves, never failing when the need is greatest. Thank You for that reminder of who You are. We are tiny and tempest tossed and need You so much. Amen.

Day 221

Praying the Scriptures

Lead me in the right path, O Lord, or my enemies will conquer me. Make your way plain for me to follow.
Psalm 5:8 nlt

There is something powerful about praying God's Word. When you are wanting direction from God, here are some great prayers to guide you:

- Lead me by your truth and teach me, for you are the God who saves me. All day long I put my hope in you (Psalm 25:5 nlt).
- Teach me Your way, O Lord, and lead me on a level path (Psalm 27:11 amp).
- Yes, You are my rock and my fortress; for Your name's sake You will lead me and guide me (Psalm 31:3 amp).
- Send out your light and your truth; let them guide me. Let them lead me to your holy mountain, to the place where you live (Psalm 43:3 nlt).

Thank You for Your Word to lead me, Lord God.

Day 222

Wiped Away

*God, in his grace, freely makes us right in his
sight. He did this through Christ Jesus when
he freed us from the penalty for our sins.*

ROMANS 3:24 NLT

Saying you're righteous is the same as saying you're blameless. And that's what God says about you. Once you put your faith and trust in Jesus, every trace of your past rebellion against God is wiped away. It's as though you lived Jesus' life, morally perfect and wholly good. What's more, this righteousness covers your future as well as your past. Anytime you stumble, go straight to God. Confess what you've done. You can trust it's forgiven *and* forgotten.

*Dear Father, we praise You for Your undeserved kindness to
us and our undeserved righteousness through Jesus Christ.
There is nothing we can say except thank You. There is
nothing we can do except praise You for the forgiveness
that covers our past and extends into our future. Amen.*

Day 223
That Morning

You have placed your faith and hope in God because he raised Christ from the dead and gave him great glory.
1 PETER 1:21 NLT

Have you ever wondered how Mary felt that Easter morning when she discovered Jesus' tomb empty? Already grieving, imagine the shock of discovering the body of her Savior—the one who held all her hopes and dreams—gone! How can that be? Maybe. . . ? Hope glimmers. But no—impossible. He *did* say something about resurrection, but that was figurative, wasn't it? Who are. . .*It's You?* I must run and tell them. It's true! He has risen! He's alive! My hope lives too!

Dear Father, we praise You that You did not let Your Holy One see decay, that the grave could not contain Him! Jesus is alive! And because He lives, I can too. I praise You that I do not need to fear death because it is the gateway to eternal life. Amen.

Day 224

In Everything

Where can I go from your Spirit? Where can I flee
from your presence? If I go up to the heavens, you
are there; if I make my bed in the depths, you are
there. If I rise on the wings of the dawn, if I settle
on the far side of the sea, even there your hand will
guide me, your right hand will hold me fast.
PSALM 139:7–10 NIV

God has promised to be with you in everything. He has the
tools you need for every job and the map you need for every
journey. If He asks you to go somewhere or do something,
He'll always provide exactly what you need at the right time.
And you can count on Him to keep His promises. He is always
going before you and working everything out for your good
and His glory!

Father, thank You for providing everything
I need. I trust in Your promises.

Day 225

Glorious Benefits

God sent Christ to be our sacrifice. Christ offered his life's blood, so by faith in him we could come to God.
ROMANS 3:25 CEV

It's easy to focus solely on the glorious benefits of believing in God. Gifts like forgiveness, eternal life, a fresh start, and unconditional love are certainly worth celebrating. But each of these gifts comes at a very high cost. Jesus paid for them with His life. Jesus' sacrifice involved physical suffering, humiliation, betrayal, and separation from His Father. Choosing to follow Jesus will involve sacrifice on your part. Allow Him to show you how sacrifice can lead to something good.

Dear Lord, sometimes (or often, if we're being honest) we grumble about the suffering we are going through. Forgive us. Let us instead praise You for the suffering You allow us to experience. That is how, in Your inscrutable mercy, You are forming us into the likeness of Your Son. Amen.

Day 226
Stay Alert

Keep awake! Watch at all times. The devil is working against you. He is walking around like a hungry lion with his mouth open. He is looking for someone to eat. Stand against him and be strong in your faith.

1 PETER 5:8–9 NLV

Even though the enemy knows he has already been defeated by Jesus, he is still trying his best to get into your head and discourage you so you won't be able to live well for Jesus. That's why Jesus wants you to stay alert. Satan is the father of lies (John 8:44), so don't fall for his tricks. You have power in the name of Jesus to get rid of any evil you come up against (James 4:7). You don't have to be afraid, just alert. Don't focus on fearing the enemy. Focus on Jesus and His power to fight your battles!

Lord, help me to stay alert and not fall for any of the enemy's tricks.

Day 227

Guilt-Free

I will forgive their wickedness, and I
will never again remember their sins.
HEBREWS 8:12 NLT

Guilt. It tends to consume us women to the point that 90 percent of the things we do are motivated by guilt. But God says we don't have to allow guilt to control us. We should learn from past mistakes, certainly, and then shed the guilt like a moth-eaten winter coat. Don a fresh spring outfit, and look ahead. Our past prepares us for the future if we are open to the present.

Dear Lord, forgive me for holding on to my mistakes and
wallowing in guilt—as if You had only covered some
of my sins with Your forgiveness. Thank You for what
my sins have shown me about myself and my choices;
thank You for washing me whiter than snow. Amen.

Day 228

Living Loved

There is no fear in love. Perfect love puts fear out of our hearts. People have fear when they are afraid of being punished. The man who is afraid does not have perfect love. We love Him because He loved us first.

1 JOHN 4:18–19 NLV

God is not angry with you. Because He sees you through the love and sacrifice of Jesus, you can always approach Him without fear! A person who is afraid of God's punishment doesn't understand who she is in Christ. You don't have to work harder or be a better Christian to earn God's love. When you begin to believe who you are in Christ, everything changes. You start living differently. You realize how deeply loved you are, and that realization sets you free. As Jesus pours His love and His Spirit into your life, His love and power spill over into the lives of those around you.

You loved me first, Father. That's how I know what love is. I'm forever grateful.

Day 229

Nothing More. . .or Less!

*Jesus. . . There is salvation in no one else! God has given
no other name under heaven by which we must be saved.*
Acts 4:11–12 nlt

God created you to live forever with Him. But like every other
person since the dawn of time, you turned away from God
to live life on your own terms. Yet God didn't give up on you.
He sent His Son to pay the heavy price of your rebellion, to
sacrifice His life for yours. When you place your faith in Jesus,
you accept this gift. Your salvation's complete. There's nothing
more or less you can do to be saved.

*Lord, this is a gift that You are—even now—extending
to everyone. It's not an exclusive club; it's not only
for the rich or the poor, the beautiful or the very bad.
It's for all who believe. Thank You for my salvation.
Help me tell others about it with joy. Amen.*

Day 230

Don't Give Up

If a man does things to please the Holy Spirit, he will have life that lasts forever. Do not let yourselves get tired of doing good. If we do not give up, we will get what is coming to us at the right time.
GALATIANS 6:8–9 NLV

Quitters give up because they've run out of their own strength. They have nothing left to give, so they give up in defeat. But followers of Jesus depend on His strength. And it never runs out. Remember that His power shines through in our weakness. Allow Him to be your strength. Invite Him to give you power through His Spirit who is alive in you. Keep coming back to God every day in prayer, trusting that He is going before you.

Lord, thank You that I don't have to depend on my own strength. I'd much rather count on Yours instead.

Day 231
Climb In

*May the God of hope fill you with all joy and peace
as you trust in him, so that you may overflow
with hope by the power of the Holy Spirit.*
ROMANS 15:13 NIV

Trust is the bottom line when it comes to living an abundant life. We will never escape the muddy ruts without trusting that God has the leverage and power to pull us out of the quagmire. They say faith is like believing the tightrope walker can cross the gorge pushing a wheelbarrow. Trust is climbing into his wheelbarrow. Only when we climb into God's wheelbarrow can His joy and peace overflow as hope into our hearts.

*Lord, often what we see in front of us seems impossible.
We can't see any way out. But we thank You that
when things seem impossible, that is when we see You
most clearly at work. Help us trust You when the way
ahead looks as daunting as a high wire. Amen.*

Day 232

Peace in the Midst of Problems

Let the peace of Christ rule in your hearts,
since as members of one body you were
called to peace. And be thankful.
COLOSSIANS 3:15 NIV

When you let peace have power over your heart, it means that you have an inner calm that comes from trusting Jesus. When problems come, and they will, you trust in Jesus and His power over anything. When you get in the daily habit of praying and taking all your problems, worries, and concerns to Jesus, you begin to experience the kind of peace that Jesus offers. When you're dealing with stress or too many things that are going on at once, turn your focus off yourself and onto Jesus and others. Help someone else. Turn on the praise music. And thank God for His peace in your heart.

Lord, help me to focus on You daily, to look at
You and Your power instead of my problems.

Day 233

Secure and Immovable

*I am sure that nothing can separate us from
God's love—not life or death, not angels or
spirits, not the present or the future.*
ROMANS 8:38 CEV

You can feel secure in your relationship with God. God doesn't suffer from mood swings or bad hair days. He isn't swayed by popular opinion or influenced by what others have to say about you. God's love, His character, His gift of salvation, and every promise He's ever made to you stands firm, immovable. You can lean on Him in any and every circumstance, secure in the fact that He'll never let you down.

*Dear Father, it is an immeasurable blessing to be loved
in this way by You. I do not love like this. My love
is fickle, forgetful, and frail. Forgive me. Help me to
better learn how to love those around me by studying
Your unfailing love. Spirit, love through me. Amen.*

Day 234

Hope Resurrected

We had hoped that he would be the one to set Israel free!
But it has already been three days since all this happened.

LUKE 24:21 CEV

The scenario for this scripture is quite unusual. Two of Jesus'
disciples are describing their lost hope due to the events
surrounding Jesus' death to none other than Jesus Himself.
They don't recognize Him as they walk together on the road to
Emmaus after His resurrection. Spiritual cataracts blind them
to the hope they thought was dead—right in front of them!

Let's open our spiritual eyes to Jesus, who is walking
beside us.

God, we laugh at the disciples complaining to the risen
Lord that He wasn't who they had hoped He was! We
think we would have had more discernment if we were
in their shoes. But without Your Spirit, we are equally
blind. Please open our eyes to Your nearness now. Amen.

Day 235
Help and Hope

The Spirit of the Sovereign LORD is on me, because the LORD has anointed me to proclaim good news to the poor. He has sent me to bind up the brokenhearted, to proclaim freedom for the captives and release from darkness for the prisoners.

ISAIAH 61:1 NIV

Jesus came to heal people with hurting hearts and to set people free. When he quoted the Isaiah 61 passage, he wasn't just talking about physical conditions, like healing illnesses or freeing someone from jail. He was talking about ministering to people who had broken hearts or were stuck in fear. Jesus came to bring hope to anyone who needed it. Ask Jesus to show you how He can use you to bring His hope to hurting people. He'll point you in the right direction and give you courage as you go.

Jesus, please show me how I can help hurting people.
Please give me courage to bring hope to others.

Day 236

The Ultimate Bodyguard

*Fear of the LORD leads to life, bringing
security and protection from harm.*
PROVERBS 19:23 NLT

Fear sounds like a rather dubious route to take to find security. After all, you wouldn't hire a personal bodyguard you feared would harm you. But fearing God isn't the same as being afraid of Him. Fearing God means standing in awe of Him. After all, He's the almighty Creator, our sovereign master, the righteous judge of all. But this all-powerful God is *for* you. He's on your side, fighting on your behalf. Talk about the ultimate bodyguard!

*If You are for us, Lord, who can be against us? Help us
to remember these wonderful words of life when we start
fearing things other than You. Nothing in this life—not
death, not disease, not disaster—should overwhelm
us. You are sovereign over everything. Amen.*

Day 237

Belonging to God

But now the Lord Who made you, O Jacob, and He Who made you, O Israel, says, "Do not be afraid. For I have bought you and made you free. I have called you by name. You are Mine!"

<small>ISAIAH 43:1 NLV</small>

When you're feeling insecure, God wants you to remember something: no matter where you are, you are His! He knows your name, He is with you, and you never have to be afraid in new places or situations. When Jesus Himself tells you who you are, it changes everything. You are His beloved child. He paid the price for your freedom when He gave His life for you on the cross. You have direct access to the one who sees everything and knows everything. And you can be confident in every situation.

Lord, I'm so thankful that I belong to You. Help me to be confident in the truth that You are always with me.

Day 238
Sprouts

*For there is hope for a tree, when it is
cut down, that it will sprout again.*
JOB 14:7 NASB

Have you ever battled a stubborn tree? You know, one you can saw off at the ground but the tenacious thing keeps sprouting new growth from the roots? You have to admire the resiliency of that life force, struggling in its refusal to give up. That's hope in a nutshell, sisters. We must believe, even as stumps, that we will eventually become majestic, towering evergreens if we just keep sending out those sprouts.

*Dear Lord, only You really know how often I struggle,
then give up, only to muster up hope and try again.
That perseverance can only come from You. Thank
You for not allowing me to give up. And I long for the
day when I will flourish in Your presence. Amen.*

Day 239

Eternally Present

*GOD's love, though, is ever and always, eternally
present to all who fear him, making everything right
for them and their children as they follow his Covenant
ways and remember to do whatever he said.*
PSALM 103:18 MSG

Nothing can separate us from the love of God (Romans 8:39).
Nothing. Because of Jesus and His triumphant work on the
cross, we will never be separated from God's love again. He
is constantly going ahead of us and behind us, rewriting our
story with "mercy's pen," as a popular worship song reminds
us. Instead of worrying about the next dose of hardship coming
your way, allow yourself to rest on the journey, viewing life as
a great adventure with Jesus. He is eternally present with you,
He loves you, and He is always at work in your life.

*Thank You for this great adventure, Lord. It's not
always easy, but I know You are always with me.*

Day 240
Sound Sleep

*The Lord is your protector, and he
won't go to sleep or let you stumble.*
Psalm 121:3 CEV

For small children, bedtime can be a scary time. They may be afraid of the dark, of monsters lurking under their bed, or of bad dreams disturbing their slumber. Bedtime prayers can help calm their fears. They can calm yours as well. Knowing God never sleeps can help you sleep more soundly. If you're in the dark about a certain situation, if "monsters" are threatening your peace, take your concerns to God. It's never too late to call out to Him.

*Lord, usually when it's bedtime, all I think about is
how fast I can lay my head on my pillow and shut out
the cares of the day. Forgive me for forgetting You.
Help me instead remember to pause and turn my mind
toward You in praise before I go to sleep. Amen.*

Day 241

Counting on It

*Blessed is the one who perseveres under trial, having
stood the test, that person will receive the crown of life
that the Lord has promised to those who love him.*
JAMES 1:12 NIV

Some think that when you turn your life over to Christ, troubles are over. But if you've been a believer for more than a day, you'll realize that the Christian life is no Caribbean cruise. There will be trials; there will be tribulations. Count on it. But Jesus promises a glorious reward for our perseverance through those hard times. Count on *that* even more.

*Lord, I know that nothing in this life is perfect, and
even if I went on a Caribbean cruise, there'd probably
be a storm at sea, E. coli in the lettuce, or. . .pirates.
Only heaven—because it's Your dwelling—is perfect.
Thank You for what waits for me in eternity. Amen.*

Day 242

Personal, Loving God

Because I am GOD, your personal God, The Holy
of Israel, your Savior. I paid a huge price for
you. . . . That's how much you mean to me! That's
how much I love you! I'd sell off the whole world
to get you back, trade the creation just for you.
ISAIAH 43:4 MSG

Do you believe God loves you this much? You are of great worth to God. He would trade the whole world to get you back! He is your own personal God, with you always, going ahead of you forever. How does that make you feel? God wants your friends and family to know this too. Ask Him for courage to share His love with others.

Thank You for Your amazing love for me, God.
Please help me have the courage to love others
and to share with them where my love comes from.

Day 243

Blossoms

*The godly will flourish like palm trees. . . . Even in old age
they will still produce fruit; they will remain vital and green.*
PSALM 92:12, 14 NLT

As you grow close to God, you blossom spiritually. But this is
one flower that will never fade or fall. Your body will age, but
spiritually you'll continue to grow stronger and more beautiful.
The more time you spend with God, the more your character
will begin to resemble His—and the more humble you'll find
yourself in His presence. This is exactly the kind of woman
God's looking for to do wonderful things in this world.

*Dear Lord, You know how I have been struggling with
aging lately. You know the aches and pains and limitations
You've given me. Please help me to deal gracefully with
them. But more importantly, help me to grow closer to
You through them. I long for fruit that will last. Amen.*

Day 244

A Dumb Ox

*When I was beleaguered and bitter, totally
consumed by envy, I was totally ignorant, a
dumb ox in your very presence. I'm still in your
presence, but you've taken my hand. You wisely
and tenderly lead me, and then you bless me.*
PSALM 73:21–24 MSG

Have you ever felt like a dumb ox in certain situations? This comical word picture explains some of what we may have felt over our ignorance in the past. But once we invite Jesus to take our hand, everything changes. He tenderly leads us and fills us with His wisdom as we're able to take it in. As we grow in our relationship with Jesus, He blesses us immensely with His presence and His love. We no longer have to feel like a dumb animal. He takes away our shame and gives blessing instead.

*Thank You, Jesus, for taking away all
my shame and blessing me instead.*

Day 245

Overflowing Love

Precious in the sight of the LORD
is the death of His godly ones.
PSALM 116:15 NASB

Jesus wept. Two small words that portray the enormity of Jesus' emotion following the death of His dear friend, Lazarus (John 11:35). Jesus knew Lazarus wouldn't stay dead, that he'd soon miraculously rise from the grave. So why did Jesus weep? The depth of His love for those precious to Him overflowed. Our Lord grieves with us in our losses today and comforts us with the knowledge that His beloved will rise to eternal life in heaven.

> *Lord, I am comforted to see that death is a horror*
> *to You too. It is wrong; it is ugly; it was not part of*
> *Your plan. You also long for the day when death's*
> *tentacles will be unwrapped from Your beautiful*
> *world, and we will all live together forever. Amen.*

Day 246

Ahead and Behind

*For the LORD will go ahead of you; yes,
the God of Israel will protect you from behind.*
ISAIAH 52:12 NLT

Yes, our great God is striding ahead of us. He is before us and behind us and with us always. There are many scriptures to support this constant truth. Let this be our heartfelt prayer: "Train me, GOD, to walk straight; then I'll follow your true path. Put me together, one heart and mind; then, undivided, I'll worship in joyful fear. From the bottom of my heart I thank you, dear Lord; I've never kept secret what you're up to. You've always been great toward me—what love!" (Psalm 86:11–13 MSG).

*Thank You, Lord, for all You've taught me and
made known to me from Your Word. I choose
not to live in fear because I know You are ahead
of me, behind me, and alive inside me.*

Day 247

Step-by-Step

I can do everything through Christ, who gives me strength.
Philippians 4:13 nlt

Picture yourself in a race, struggling to reach the finish line.
You're exhausted, discouraged, perhaps even injured. You're
tempted to give up. Then a friend runs onto the course from
the sidelines. She places her arm around your waist, inviting
you to lean on her for strength and support. Together, step-by-
step, you see the race to completion. God is that kind of friend.
Whether the strength you need today is physical, emotional,
or spiritual, God is there. Lean on Him.

*Father, thank You for coming alongside me when I am
weary. I feel Your comfort and strength flow into me
as I meditate on Your Word, when I pray, and when I
gather to speak of You with other believers. Thank You
for meeting me right here in my weakness. Amen.*

Day 248

No Call-Waiting

*Call on me and come and pray
to me, and I will listen to you.*
JEREMIAH 29:12 NIV

"I will listen to you." Every woman's dream.

Jeremiah knew the importance of being listened to. He proclaimed God's message for forty years to the unseeing, unhearing, unresponsive nation of Judah. His ironic good news: God is listening!

Do you ever feel like no one's listening? The Bible says God hears us every time we utter His name. How precious we are to our Creator that He bends His omnipotent ear each time we call on Him.

*Dear God, thank You that we don't need to shout for
You to respond. Thank You for hearing us when we
are too troubled even to form words. You understand
groans, sobs, whimpers, shrieks. Help us to call on You
more and more; thank You for always listening. Amen.*

Day 249

He Is Right There with You

The LORD is my shepherd; I shall not want.
PSALM 23:1 NKJV

We're going to take a look at The Passion Translation to gain more meaning into Psalm 23. It's famous at funerals, but this psalm has great meaning and power for your everyday life. The word "shepherd" comes from the Hebrew root word *ra'ah*, which means "best friend." The Passion Translation says, "Yahweh is my best friend and my shepherd. I always have more than enough." Commit to staying close to your shepherd, Jesus. He will always lead you on the right path. He will refresh and restore your life, making you strong. Pray that Jesus continues to make His voice known to you.

Jesus, thank You for caring for me like a gentle
shepherd and best friend. I will follow You, Jesus.
Help me to recognize You as You speak to me.

Day 250

A Second Wind

Strength is for service, not status. Each one of us
needs to look after the good of the people around
us, asking ourselves, "How can I help?"
Romans 15:1 MSG

When you're feeling worn out, it's hard to think about meeting anyone's needs other than your own. But sometimes that's exactly what God asks you to do. Perhaps it's your children who need your help in the middle of the night. Or maybe it's a stranger whose car has broken down by the side of the road. When God nudges you to respond, call on Him for strength. His Spirit will rouse your compassion, providing you with a second wind.

Lord, I am tired today, but I know You have put
me in a place where I can serve the needs of many.
Help me to put aside how I feel, to rely on Your
strength, and to rejoice that You supply my every
need so I can meet the needs of others. Amen.

Day 251

He Makes Me Lie Down

He makes me to lie down in green pastures;
He leads me beside the still waters.
PSALM 23:2 NKJV

The Passion Translation says, "He offers a resting place for me in his luxurious love. His tracks take me to an oasis of peace near the quiet brook of bliss." It has been said that sheep need four things to be able to lie down: (1) freedom from fear, (2) freedom from friction with other sheep, (3) freedom from being tormented by pests, and (4) freedom from hunger. This was explained by a pastor who said, "The way for sheep to be free of these is to be keenly aware that the shepherd is nearby. So also can we lie down to rest because God's Spirit within us reassures us that He is aware and deeply involved in our lives."

Lord, I'm so thankful for the peaceful rest You offer me.

Day 252

Close to You

I stay close to you, and your powerful arm supports me.
PSALM 63:8 CEV

There's an old saying: "I used to be close to God, but someone moved." If God is the same yesterday, today, and tomorrow, He's not the one going anywhere. So how do we stay close to God? So close that His powerful arm supports us, protects us, and lifts us up when we're down? Prayer—as a lifestyle, as much a part of ourselves as breathing. Prayer isn't just spiritual punctuation; it's every word of our life story.

Dear Lord, forgive me for the times I have forgotten to pray. . .when I've been busy, preoccupied, or intent on doing things on my own. I long to live under Your powerful, protective arm. Teach me daily to turn to You, and guide me into a lifestyle of prayer. Amen.

Day 253

All the Days of My Life

*Surely goodness and mercy shall follow me all the days of
my life; and I will dwell in the house of the Lord forever.*
PSALM 23:6 NKJV

The Passion Translation says, "So why would I fear the future?
Only goodness and tender love pursue me all the days of my
life. Then afterward, when my life is through, I'll return to your
glorious presence to be forever with you!"

How amazing that God's goodness and love actually pursue
you! Spend extended time in prayer with Him today, thanking
Him for this great truth.

*Lord God, I'm so amazed at what I'm learning about
Your great love and care for me. You're more than
a good shepherd. You are the source of life and love
and joy in my life. You pursue me because You want
a relationship with me. You are so, so good to me.*

Day 254

In Line with God's Goals

Commit to the LORD whatever you do,
and he will establish your plans.
PROVERBS 16:3 NIV

Faith's definition of *success* differs from that of the world. Whereas our culture applauds people of fame, wealth, and power, faith regards those who live their lives according to God's purpose as successful. Committing whatever you do to God isn't asking Him to bless what you've already decided to do. It's inviting Him into the planning process. Make sure your dreams and goals are in line with God's. Then get to work—leaving the end result in His hands.

Thank You, Lord, that Your plans are to prosper me.
But often I miss the most important part of that verse:
it says Your plans. Not mine. In order to succeed, my
plans need to be Your plans. Give me the wisdom to see
where You are leading and the faith to follow. Amen.

Day 255
God with Us

The virgin will conceive and give birth to a son, and they will call him Immanuel (which means "God with us").
MATTHEW 1:23 NIV

Jesus is Immanuel. This special name was foretold back in the Old Testament in the book of Isaiah, hundreds of years before Jesus was born (see Isaiah 7:14). God had a rescue plan in place for His people. John 3:16–17 (NIV) tells us why: "For God so loved the world that he gave his one and only Son, that whoever believes in him shall not perish but have eternal life. For God did not send his Son into the world to condemn the world, but to save the world through him."

God became one of us. Immanuel. He is with you always.

Jesus, I'm amazed that You became one of us.
Thank You for Your unimaginable sacrifice for me.

Day 256
A Strong Tower

The name of the LORD is a fortified tower;
the righteous run to it and are safe.
PROVERBS 18:10 NIV

We of the twenty-first century tend to limit our references to God, but ancient Hebrew translations offer a broader perspective. There is intrinsic hope in the names of God: *Elohim* (Mighty Creator), *El Olam* (The Everlasting God), *Yahweh Yireh* (The Lord Will Provide), *Yahweh Shalom* (The Lord Is Peace), *Yahweh Tsuri* (The Lord, My Rock), and *Abba* (Father) to name a few. Let's broaden our scope of His powerful name in our prayers today.

> *Dear God, all those names are not just descriptions*
> *of You but solid, actual truth—the Word made flesh.*
> *We praise and thank You for who You are. We trust*
> *in all Your names; they are all true, all the time, for*
> *all people, in all places. Who is like You? Amen.*

Day 257

Held Together

He is before all things, and in him all things hold together.
COLOSSIANS 1:17 NIV

Jesus is more powerful than anything you can imagine, and yet He loves and cares for you. He knows everything about you, and He cares about the things you're going through. Sometimes that can be hard to believe, but the Bible tells us it is true. And Jesus will show up and be very real in your life if you let Him. Are you facing a problem that feels too big or too small for God? Talk to Him about it. Tell Him how you really feel. Ask Him to help you believe that He cares about every little thing—and every big thing too. The closer you get to Jesus, the more your thoughts begin to match up with His thoughts.

*Lord, I'm amazed that You truly care so much
for me. Thank You for holding me together.*

Day 258
God at Work

*Give thanks in all circumstances; for this
is God's will for you in Christ Jesus.*
1 THESSALONIANS 5:18 NIV

Faith gives you new eyes, along with a new heart. As you look more consistently in God's direction, you become aware of things you never noticed before. . .the miraculous detail of God's creation, the countless gifts He gives each day, His answers to prayer, and His persistence in bringing something positive out of even the most negative circumstances. It's good to notice God at work. It's even better to say "thank You" when you do. What will you thank Him for today?

*Lord, I thank You for the view outside my window, for
the warm clothes I am wearing, for the smell of pancakes
from the kitchen, for the voices of my children and
husband, for the clink of forks on plates. You are present
in this house this morning, and I praise You. Amen.*

Day 259
One Gutsy Gal

It could be that you were made
queen for a time like this!
ESTHER 4:14 CEV

Crowned queen after winning a beauty contest, Esther was only allowed audience with her king when summoned. A wave of his scepter would pardon her from execution, but he was a hard man—and unpredictable. When Esther learned of a plot to destroy her people, she faced a tough decision. She was the *only* one who could save them—at supreme risk. God had intentionally placed her in that position for that time. What's your divinely ordained position?

Lord, my divinely ordained position is simply where
You have placed me right now. Esther didn't have to do
anything except what was right in front of her at that
moment. But it was hard, Lord. And dangerous. Give me
the courage to act when and how You desire. Amen.

Day 260
History

*And he made from one man every nation of mankind to
live on all the face of the earth, having determined allotted
periods and the boundaries of their dwelling place, that
they should seek God, and perhaps feel their way toward
him and find him. Yet he is actually not far from each one
of us, for "In him we live and move and have our being."*
ACTS 17:26–28 ESV

God knows your name and everything about you. He set you
on earth at this exact time in history for a purpose. He wants
you to know Him. He wants you to love Him and love others
through Him. You matter greatly to God, and He has wonderful
plans for your life.

*Lord, I'm coming to believe the truth of Your great love for
me personally. I want what You want for my life. Thank
You for placing me at this spot in Your great story.*

Day 261
What Lies Ahead

The word of the LORD holds true,
and we can trust everything he does.
PSALM 33:4 NLT

You confide in a friend, because she's proven herself faithful over time. She won't lie. What she says she'll do, she does. You trust in her love, because you believe she has your best interests at heart. God is this kind of friend. It takes time to build your own track record of trust with Him. As you do, consider His faithfulness to those in the Bible. God's past faithfulness can help you trust Him for whatever lies ahead.

Lord, it's probably a good thing that we can't see the
future. Instead, like children clinging to the protective
hands of a father, we hold fast to the one who holds
the future. You will never fail us. What we do know
is that You are faithful and will prevail. Amen.

Day 262

One Spirit

But the person who is joined to
the Lord is one spirit with him.
1 Corinthians 6:17 NLT

Let these scriptures encourage you today:

- Yet for us there is but one God, the Father, who is the source of all things, and we exist for Him; and one Lord, Jesus Christ, by whom are all things [that have been created], and we [believers exist and have life and have been redeemed] through Him (1 Corinthians 8:6 AMP).

- God is faithful [He is reliable, trustworthy and ever true to His promise—He can be depended on], and through Him you were called into fellowship with His Son, Jesus Christ our Lord (1 Corinthians 1:9 AMP).

Lord, You are faithful, reliable, trustworthy, and
true to Your promise. I know I can depend on
You always. I'm thankful that Your Spirit is in
me and that You've filled me with new life.

Day 263

Cool Summer Shower

He will renew your life and sustain you in your old age.
RUTH 4:15 NIV

Ruth's blessing of renewal is applicable to us today. *Renovatio* is Latin for "rebirth." It means casting off the old and embracing the new: a revival of spirit, a renovation of attitude. Something essential for women to espouse every day of their lives. Like a cool rain shower on a sizzling summer day, Ruth's hope was renewed by her Lord's touch, and ours will be too, if we look to Him for daily replenishing.

Dear Father, we try to find renewal in so many ways,
but true renewal only comes from You. Thank You that
Your refreshing can come in the midst of heartache,
suffering, waiting—You are larger than any of those
things. Fill us, Lord, with the balm of Your Spirit. Amen.

Day 264
Prayer Life

He is not weak or ineffective in dealing with you,
but powerful within you. For even though He was
crucified in weakness [yielding Himself], yet He lives
[resurrected] by the power of God [His Father]. For
we too are weak in Him [as He was humanly weak],
yet we are alive and well [in fellowship] with Him
because of the power of God directed toward you.
2 CORINTHIANS 13:3–4 AMP

We can have a deep and meaningful prayer life because of this truth. Prayer is about relationship. Talk to God now in your heart or out loud, and wait for His response. Sometimes He will point you to a scripture. Sometimes He will put a picture in your imagination. He might put a worship song in your mind. He may impress your heart with a strong idea or thought. Our Creator can speak to us in unlimited ways.

God, I believe in Your unlimited power directed toward me.
I want to hear from You in any way You want to speak.

Day 265
Trust the Truth

Jesus answered, "I am the way and the truth and the life. No one comes to the Father except through me."
JOHN 14:6 NIV

Believing all good people go to heaven sounds nice. But it doesn't make sense. How do you measure goodness? Where's the cutoff between being "in" and being "out"? Spiritual truth cannot be relative or change according to how we feel. It must be timeless, steadfast—like Jesus. Jesus said that putting our faith in Him is the only way we can be reconciled with God and receive eternal life. Trust the truth. Trust Jesus.

Lord, it seems too simple. We want to do something to earn our salvation. But praise God, Jesus did it all on the cross, and we don't need to—and actually can't—add anything to that. Help us rest and rejoice in the finished work of Christ. Amen.

Day 266
Honesty

I pray to you, O LORD, my rock. Do not turn a deaf ear to me. For if you are silent, I might as well give up and die. Listen to my prayer for mercy as I cry out to you for help, as I lift my hands toward your holy sanctuary.
PSALM 28:1–2 NLT

You can be totally honest with God. You can't hide anything from Him anyway. Notice that the Psalms are full of brutal honesty. God is the safest place for you to share everything. He can shine His light on all your thoughts and feelings and help you work them out. Ask God to bring anything to light that needs to be discussed and worked through.

God, I am thankful that You are a safe place. Cast away my fears. I want to be totally honest with You. Help me long for You and desire to be with You every day.

Day 267

The Salvage Master

We are pressed on every side by troubles, but we are not crushed. We are perplexed, but not driven to despair.

2 CORINTHIANS 4:8 NLT

Many women struggle with depression at some point in their lives: postpartum, kids-partum (empty nest), brain-partum (menopause), and anytime in between. We feel that we are being compressed into a rock-hard cube like the product of a trash compactor. The normal details of life suddenly become perplexing and overwhelming. But God does not abandon us to the garbage dump. He is the salvage master and recycles us into sterling images of His glory.

Dear Lord, when my mind is foggy or low, let me press into You for clarity and comfort. You promise both. You promise I will not be crushed or driven to despair. Help me persevere in reading Your Word and praying until You answer. He who promises is faithful. Amen.

Day 268

Everything Is Possible

Jesus looked at them intently and said,
"Humanly speaking, it is impossible.
But with God everything is possible."
MATTHEW 19:26 NLT

What Jesus wants one person to do is not necessarily the same exact thing He wants you to do. Jesus is all about relationship. He is a very personal God. He wants to be your friend and your trusted counselor. He wants you to come to Him first for advice. What do you need advice about today? Ask Jesus for help and guidance. Talk to Him like you would talk to your best friend. You can talk to Him out loud, or you can pray in your heart and mind. And writing down your prayers so you can have a reminder of how God answers is also very helpful.

God, I believe that everything is possible
with You leading me. I trust You to equip
me for whatever You're calling me to do.

Day 269

The Perfect Harvest

The LORD longs to be gracious to you; therefore he
will rise up to show you compassion. For the LORD is
a God of justice. Blessed are all who wait for him!
ISAIAH 30:18 NIV

God is the master of perfect timing because He can see straight across the grand scheme of history. He can tell if what you're waiting for today would be even better if it was received tomorrow—or years down the road. As you grow in your faith, you'll grow to trust God's timing more and more. Expect Him to surprise you with the perfect harvest, always delivered at exactly the right time.

Lord, You see the end from the beginning. From the
vantage point of heaven, our stories are already told,
finished in surprising and glorious ways. Help us trust
that what Your hands have written will be just what
we need and desire most. In love and faith, amen.

Day 270

Makeover

Since I was worse than anyone else, God
had mercy on me and let me be an example
of the endless patience of Christ Jesus.
1 Timothy 1:16 cev

Saul was a Jesus hater. He went out of his way to hunt down believers to torture, imprison, and kill. Yet Christ tracked *him* down and confronted him in a blinding light on a dusty road. Saul's past no longer mattered. Previous sins were forgiven and forgotten. He was given a fresh start. A life makeover. We too are offered a life makeover. Christ offers to create a beautiful new image of Himself in us, unblemished and wrinkle-free.

Dear Lord, thank You that when we first come to
You in repentance, You forgive our sins and forget
them—completely. They are gone, drowned in Your
mercy. We praise You that Your forgiveness is so deep
and wide. Thank You for making us over. Amen.

Day 271
When God Helps

*The LORD is my strength and shield. I trust him with all
my heart. He helps me, and my heart is filled with joy.
I burst out in songs of thanksgiving. . . . Lead them like
a shepherd, and carry them in your arms forever.*
PSALM 28:7, 9 NLT

When God helps, He turns darkness and stress and sadness
into joy and singing and thanksgiving! It's always a process.
God values you, and He is careful with you. He leads you like
a gentle shepherd carries his sheep. When you allow Him to
help you work through your issues and feelings, miraculous
things happen. He knows exactly what you need and how
to get you from one step to the next. Picture yourself being
carried in the arms of Jesus. What truth does He want you to
remember forever?

Thank You for being gentle with me, Lord Jesus.

Day 272

Power and Purpose

He delivered us and saved us and called us with a holy calling [a calling that leads to a consecrated life—a life set apart—a life of purpose], not because of our works [or because of any personal merit—we could do nothing to earn this], but because of His own purpose and grace [His amazing, undeserved favor] which was granted to us in Christ Jesus before the world began [eternal ages ago].

2 TIMOTHY 1:9 AMP

Jesus saves us and delivers us from our fears so that we can live a life of purpose. Ask Jesus to make His purpose for you clear. What are your gifts and talents? What stirs your heart in life-giving ways? Pray and listen as God writes this purpose on your heart. Make sure you write down any answer God is giving you. He will always confirm His truth for you if you ask Him.

Jesus, I'm so thankful that You want to replace my fears and anxieties with Your power and purpose.

Day 273

Hearing from God

My sheep listen to my voice;
I know them, and they follow me.
JOHN 10:27 NLT

Have you limited the way God is "permitted" to speak to you?
Consider the ways that you are comfortable hearing from God:
through His Word, through a pastor, through music, through
nature? Jesus respects our boundaries. If you've put bound-
aries, limits, and walls between you and God and what He is
"allowed" to do in your life, your prayer life could be suffering.
Ask God to break down and break through any walls you have
built that might be creating a feeling of distance between you
and God. Ask God to show Himself to you in new ways. Be
open to the work of the Holy Spirit in your heart.

I don't want to put limits on You, Lord.
Break down any walls that I've created that
might prevent me from hearing from You.

Day 274

Wings

This means that anyone who belongs to Christ has become a new person. The old life is gone; a new life has begun!
2 CORINTHIANS 5:17 NLT

Have you ever seen a butterfly crawling on her belly with caterpillars? Or trying desperately to hang on to her cocoon as she takes to the skies? Of course not—she spreads her wings and flies far away from her old life, discovering new and wonderful things she never knew existed.

New life in Christ is full of discoveries and wonders, but you can't get there if you're still clutching the old life. It's time to let go, sister.

Dear Father, thank You for offering me a completely new life in Christ. I don't have to hold on to the past; it has no hold on me. Help me to see where I am clutching things You want me to put down. Open my hands so that You can fill them. Amen.

Day 275
The Good Shepherd

*I am the Good Shepherd. The Good
Shepherd gives His life for the sheep.*
JOHN 10:11 NLV

Jesus tells us that He is our Shepherd. A good and gentle shepherd would love and care for his sheep with compassion and kindness. A shepherd needed the sheep to listen to him so they could travel to the best places for food. When the shepherd walked ahead of them, they followed him because they knew his voice. Jesus calls us His sheep, and He lovingly cares for each of us! Today's verse reminds us that our Shepherd even gave His very life for us! When we get to know His voice, we can be sure we're following someone we can trust.

*Jesus, You are my loving Shepherd. I follow You
because I trust You and know that I can count
on You to lead me in the right direction.*

Day 276

We Are His Sheep

When he saw the crowds, he had compassion
on them because they were confused and
helpless, like sheep without a shepherd.
MATTHEW 9:36 NLT

Sheep are born with an instinct to follow the leader. If one sheep does something dangerous or stupid, the sheep behind it usually follow. When Jesus came to earth, He saw that the people were acting like sheep without a shepherd—making bad choices and following others who were also making bad choices. Some people look at people making bad decisions and have no compassion for them. They judge them harshly and leave them to their consequences. But not Jesus. The Bible says that He had compassion on these people. He knew what caused them to make those choices. He loved them and wanted to help.

Jesus, thank You for leading me. Help me to be the kind
of leader that has compassion and love for others.

Day 277

Look to the Sunrise

I rise before dawn and cry for help;
I have put my hope in your word.
PSALM 119:147 NIV

Could be stress or worry or berserk hormones. Whatever the cause, many women find themselves staring at their dark bedroom ceilings in the wee morning hours. We try counting sheep, but they morph into naughty little children, and we exhaust ourselves chasing them through fitful dreams. We're tormented by the what-ifs, guilted by the should-haves, and jolted wider awake by the don't-forget-tos. But a new day is dawning and help is but a prayer away.

Lord, when I wake in the night, assaulted by worry, help
me to take my eyes off myself and turn them to Jesus.
Fill my mind with thanksgiving; fill my heart with praise;
fill my mouth with prayers to the living, listening God.
Both sleeping and waking are gifts from You. Amen.

Day 278

Close to the Shepherd

If a man has a hundred sheep and one of them wanders away, what will he do? Won't he leave the ninety-nine others on the hills and go out to search for the one that is lost? And if he finds it, I tell you the truth, he will rejoice over it more than over the ninety-nine that didn't wander away! In the same way, it is not my heavenly Father's will that even one of these little ones should perish.

MATTHEW 18:12–14 NLT

Good shepherds don't want to lose any of their sheep. You matter so much to Jesus that if you ever go wandering off, He'll search for you too! When we stay close to our shepherd, He leads us to the right places. When we wander off, we can get lost, hurt, and confused. But Jesus will always come for us.

Jesus, help me stay close to You. Lead me on the right path.

Day 279

Bring Your Plans to Jesus

*In all your ways know and acknowledge and recognize
Him, and He will make your paths straight and
smooth [removing obstacles that block your way].*
PROVERBS 3:6 AMP

Decision-making is not as difficult as we make it. When we forget that God wants to help us make choices, we get confused and anxious. When we leave God out of the decision-making process, it causes lots of unnecessary problems. Confess this truth to God in prayer. Ask forgiveness for the times you've left God out of the equation. Repent, and ask God to help transform your thinking in this area. Listen for His voice as you go about your day, and He'll be with you, leading you in the right direction.

*Lord, I trust that You care about everything I
have on my schedule. I invite You to be a part
of every plan and every decision. Remind me
that You're here when I start to forget You.*

Day 280

He Won't Let You Down

*He didn't tiptoe around God's promise asking
cautiously skeptical questions. He plunged into the
promise and came up strong, ready for God, sure
that God would make good on what he had said.*

ROMANS 4:20 MSG

If there is one thing you can count on for all eternity, it's that God will never let you down. Oh, you may think He has let you down or that He will in the future because something happened that you don't understand, but only God sees all and knows all. You can trust His character. You can trust that He is good. All the time. He doesn't have poor thoughts toward you—even when you mess up. Jesus already took all that punishment. God is not mad at you. He is not disappointed in you. He looks on you with love because of Jesus. And He will never let you down.

I trust in Your goodness, God.

Day 281

A Strong Foundation Matters

Whoever hears these words of Mine and does them, will be like a wise man who built his house on rock. The rain came down. The water came up. The wind blew and hit the house. The house did not fall because it was built on rock.
MATTHEW 7:24–25 NLV

Jesus tells this story in Matthew to teach us about life as a Christian. If we build our lives on the firm foundation of Jesus, we won't fall apart when hard things happen. We trust in God! But if we don't have a solid foundation in Jesus, not knowing or believing His truth for our lives, we can fall apart when storms and bad things happen to us. Put your trust in the solid rock of Jesus. He will never let you fall!

Jesus, I know You are my strong foundation that will be with me no matter what storms come my way.

Day 282

Desert Oasis

Yes, my soul, find rest in God; my hope comes from him.
PSALM 62:5 NIV

Rest. Far too elusive in our world of bustling busyness. Overwhelming responsibilities run us ragged. We find ourselves not just physically frazzled but bankrupt of spirit. Exhaustion steals our joy.

Like an oasis in the desert, our Father offers rest for our weary souls and restores our hope. He helps us unload our burdens, relax beside His still waters, and drink in the sparkling refreshment of truth.

> *Lord, forgive us for so often putting You last on our*
> *to-do list. Forgive us for reading Your Word or praying*
> *when we have the time instead of putting You first.*
> *Help us to realize that our days are gifts from You*
> *and to find rest in You before anything else. Amen.*

Day 283

Our Safe Place

*God is our safe place and our strength. He is
always our help when we are in trouble. So we
will not be afraid, even if the earth is shaken and
the mountains fall into the center of the sea.*
PSALM 46:1–2 NLV

The Bible tells us that God is our safe place. People, relationships, and circumstances change, but your safe place in God will never change. You can always count on Him to be the same. And you never have to be afraid when He is close. He wants to protect you, comfort you, and tell you how loved you are. Sometimes sitting in the quiet with God is the best way to pray. Ask Him to fill you with His love as you sit in His presence. Picture yourself climbing into God's lap and letting Him love you.

Thanks for always being a safe place for me, Father God!

Day 284

Training in Truth

All Scripture is God-breathed and is useful for teaching, rebuking, correcting and training in righteousness.
2 TIMOTHY 3:16 NIV

The Bible tells us that our enemy, Satan, is the father of lies. He will try every trick in the book to get you to mess up. What did Jesus do when He was tempted? He told Satan the truth from God's Word. When you feel like you are being tempted to make a bad choice, ask Jesus for help. He has been there! He knows how to help you overcome. It matters to Jesus that you know there is always a way out of sin (1 Corinthians 10:13). He can help you make the right choice in the moment. When you memorize scripture, God's Spirit will help you remember those powerful words right when you need them. Start with 2 Timothy 3:16.

Jesus, when I'm tempted, help me remember Your truth.

Day 285
Chill

*I lie awake thinking of you, meditating on you
through the night. Because you are my helper,
I sing for joy in the shadow of your wings.*
Psalm 63:6–7 nlt

Are you a worrier? Do you frequently find yourself working up a sweat building molehills into mountains during the midnight hours? This passage suggests an alternative for that nasty and unproductive habit. Instead of worrying, try meditating on the loving-kindness of God. Like a distressed chick tucked safely beneath the snug wings of the mother hen, allow the joy of being loved and protected to relax your tense muscles and ease you into peaceful rest.

*Dear Lord, thank You for the example of David. He had
so many things to worry him, yet he meditated on You
when he couldn't sleep. He praised You when his soul
was hurting. Despite the dangers, he danced before You.
Help me to live like that, even in the darkness. Amen.*

Day 286

Perfect Peace

I have told you these things, so that in Me you may have [perfect] peace. In the world you have tribulation and distress and suffering, but be courageous [be confident, be undaunted, be filled with joy]; I have overcome the world. [My conquest is accomplished, My victory abiding.]

JOHN 16:33 AMP

The world God created is a beautiful place, but it's a messed-up place too. We live in a fallen world, and things won't be perfect again until Jesus returns. Jesus promises us that this world will have trouble because it's not heaven. We can't expect it to be. It's time to let go of your expectations of what this world should be. Embrace the reality and goodness of God's peace and presence in the midst of a dark world.

Jesus, I want the perfect peace that only You offer. Help me embrace the reality that You are here to help me through this life with Your peace.

Day 287
Power and Love

But the Lord is the true God. He is the living God
and the King Who lives forever. . . . It is He Who
made the earth by His power, and the world by His
wisdom. By His understanding He has spread out
the heavens. When He speaks, there is a storm of
waters in the heavens. He makes the clouds rise from
the ends of the earth. He makes lightning for the rain,
and brings out the wind from His store-houses.
JEREMIAH 10:10, 12–13 NLV

The God who loves and cares about you is the same God who
stretched out the heavens. It might be hard to believe that you
matter so much to God, but the Bible tells us it's true. When
you think about God's unlimited power and His love for you,
do you trust that God can handle anything you have going on?

Father, if You can speak water into existence
at the sound of Your voice, I know You can
take care of anything that comes my way.

Day 288
God Sings

The LORD your God is with you, the Mighty Warrior who saves. He will take great delight in you; in his love he will no longer rebuke you, but will rejoice over you with singing.
ZEPHANIAH 3:17 NIV

Getting to know God through reading His Word and prayer will change your life. He changes your thoughts to match His thoughts. As you get to know God, you will find that He's so much more than you ever thought possible. He is all-knowing, all-powerful, the Savior of the world—and yet the Bible tells us that He sings over us! God delights in You. He sees you through the eyes of Jesus. Nothing can make Him love you more or less. You cannot work for God's love. It just is.

Lord, I want to know Your words and Your truth for my life. I accept Your great love for me.

Day 289
The Exchange Line

*To bestow on them a crown of beauty instead of
ashes, the oil of joy instead of mourning, and a
garment of praise instead of a spirit of despair.*
ISAIAH 61:3 NIV

Remember the last time you were in the exchange line? That's
never fun. Did you know that God likes to exchange things?
Old for new, death for life, ashes for beauty, sadness for joy,
despair for praise. He also exchanges our weakness for His
strength. Can you picture yourself bringing everything that
you need Him to exchange and laying it at Jesus' feet? What
does He want to give you instead? Ask Him!

*God, I'm so thankful that You can turn my darkness
into light, my sadness into joy, my ashes into beauty,
and my weakness into Your strength. Please show
me what You'd like to exchange in my life.*

Day 290
Any Time

*Now that we know what we have—Jesus, this great High
Priest with ready access to God—let's not let it slip through
our fingers. . . . So let's walk right up to him and get what
he is so ready to give. Take the mercy, accept the help.*
HEBREWS 4:16–18 MSG

You've likely seen the movies where the common people need
special permission to come into the palace and see the king
or queen. They bow low before the throne and use titles of
honor to show respect. Of course God will always deserve our
respect, but we don't need special permission to go into His
presence anymore! Because of Jesus, you have the ability to
walk right up to God and talk to Him any time of the day. You
don't have to cower in fear! Jesus has made everything right
for you before God.

Father God, thank You for always receiving me.

Day 291

Showers of Blessing

*Do the skies themselves send down showers? No,
it is you, Lord our God. Therefore our hope is in
you, for you are the one who does all this.*
JEREMIAH 14:22 NIV

Have you ever stood in your parched garden, praying for rain?
The plants you've nurtured from seeds are wilting, flower pet-
als litter the ground, fruit withers on the vine. Then thunder
clouds roll and the skies burst forth with reinvigorating rain.

There will be dry times too, in our spiritual gardens, when
drought threatens to shrivel our faith. But our hope is in the Lord
our God who sends showers to revive us. Deluge us today, Lord.

*Dear Lord, You send heat and cold, rain and dry
winds. Since nothing is outside Your control, we
can thank You for the rain showers and for the dry
times. Help us to rejoice in the rain and persevere in
the droughts. Our lives are in Your hands. Amen.*

Day 292

No One Like You

There is no one like You among the gods, O Lord.
And there are no works like Yours. All the nations
You have made will come and worship before You,
O Lord. And they will bring honor to Your name. For
You are great and do great things. You alone are God.
PSALM 86:8–10 NLV

The time you spend with God will accomplish more than anything else you could ever do. Jeremiah 32:17 (ESV) says, "Ah, Lord GOD! It is you who have made the heavens and the earth by your great power and by your outstretched arm! Nothing is too hard for you." Ask God to help you believe that He can do anything! No problem is too hard, too big, or too small for God's help.

God of all creation, there is no one like You. I am so
blessed to be able to bring everything on my heart to
You in prayer and know that You want to help!

Day 293

Ask and Receive

So I say to you: Ask and it will be given to you; seek and
you will find; knock and the door will be opened to you.
For everyone who asks receives; the one who seeks finds;
and to the one who knocks, the door will be opened.

LUKE 11:9–10 NIV

James 4:2 (NIV) says, "You do not have because you do not ask God." A lot of times we forget to bring things to God first. We try to get our needs met from other people and other things when God is just waiting for us to come to Him. We can ask for anything. And as we come to Him in prayer, He aligns our hearts with His.

Lord, please help me to come to You first with all
my wants and needs. I know You want to help.

Day 294

Snippets of Hope

*I also pray that you will understand the incredible
greatness of God's power for us who believe him.
This is the same mighty power that raised Christ
from the dead and seated him in the place of honor
at God's right hand in the heavenly realms.*

Ephesians 1:19–20 nlt

Daydreams are snippets of hope for our souls. Yearnings for something better, something more exciting, something that lifts our spirits. Some dreams are mere fancy, but others are meant to last a lifetime because God embedded them in our hearts. It's when we lose sight of those dreams that hope dies.

But God offers us access to His almighty power—the very same greatness that brought His Son back from the dead. What greater hope is there?

*God, thank You for the dreams You have given
me—both the ones that have come true and the ones
that still glimmer in the distance. Thank You for how
they give me hope. But help me place my eternal hope
not on those dreams but on You, the dream giver. Amen.*

Day 295
Look and Find

*You will seek me and find me when
you seek me with all your heart.*
JEREMIAH 29:13 NIV

What does seeking God and looking for Him with all your heart mean? Check out the following verses that help us understand:

- I love those who love me, and those who seek me diligently find me (Proverbs 8:17 ESV).
- But seek first the kingdom of God and his righteousness, and all these things will be added to you (Matthew 6:33 ESV).
- Seek the LORD and his strength; seek his presence continually (1 Chronicles 16:11 ESV)!
- Come near to God and he will come near to you (James 4:8 NIV).

As you look for God in everything, you will find that He is everywhere. He never leaves you.

*Thank You for being close to me, Lord.
Help me to look for You in everything.*

Day 296

Always Knocking

*Look! I stand at the door and knock. If you hear
my voice and open the door, I will come in, and
we will share a meal together as friends.*
REVELATION 3:20 NLT

The Bible tells us we can knock on God's door and be invited in, but did you know that He is knocking on your door too? Today's scripture tells us this truth. Wouldn't the game of hide-and-seek be so easy if the person who was supposed to be hiding was actually looking for you too? That's the really amazing thing—while we're looking for God, He's looking for us! He wants you to find Him. He makes it pretty simple. If you look for Him, you *will* find Him. That's a promise!

*Jesus, I'm so thankful that You don't play games.
You want to be found. Help me seek You always.*

Day 297

Prayer Life

*Very early in the morning, while it was still
dark, Jesus got up, left the house and went
off to a solitary place, where he prayed.*
MARK 1:35 NIV

The Bible says that Jesus often went away to be alone with
God and pray. Hopefully, you are beginning to understand how
much you matter to God and why it's important to spend time
with Him. As a follower of Jesus, your power and hope and
strength to make it through each day comes from your time
spent with God. Jesus lived a life of prayer. How can you live
a life of prayer too? You invite Him into every moment of your
day. You seek His thoughts when you need help. You ask for Him
to give you love for others as you see people during the day.

*Jesus, I invite You into every moment of my day.
Remind me that You are with me at all times.*

Day 298

True Success

*"For I know the plans I have for you," declares
the Lord, "plans to prosper you and not to harm
you, plans to give you hope and a future."*
JEREMIAH 29:11 NIV

As little girls, we dream about the handsome man we'll one day marry, exciting trips we'll take, the mansion we'll call home, and the beautiful, perfect children we'll have. A *successful* life—isn't that what we hope for?

But God doesn't call us to be successful; He calls us to trust Him. We may never be successful in the world's eyes, but trust in our Father's omnipotence ensures our future and our hope. And that's true success.

*Lord, Your promises are sure. We can rest in them.
Thank You so much for Your Word, which repeats those
promises over and over in different ways to ensure that
we get it: we have a hope and a future! And because
You have already won the victory, we have too. Amen.*

Day 299

Blessing

Jabez cried out to the God of Israel, saying, "Oh that You would indeed bless me and enlarge my border [property], and that Your hand would be with me, and You would keep me from evil so that it does not hurt me!" And God granted his request.

1 CHRONICLES 4:10 AMP

Jabez asked God's blessing. And God gave it to Him! Asking for God's blessing is something we see throughout the entire Bible. Does this mean that God will always give us everything we ask for? No, because God always sees all and knows all. Something that we think might be good for us could actually turn out pretty badly. That's why we trust God's will. Asking for God's blessing is asking for His purpose and power in your life rather than asking Him to give you everything you want. God knows best.

Lord, I trust You to bless me in whatever way You choose.

Day 300

Alive in Creation

I will sing of the loving-kindness of the Lord forever. I will make known with my mouth how faithful You are to all people. . . . The heavens are Yours; and the earth is Yours. You have made the world and all that is in it.

PSALM 89:1, 11 NLV

One of the simplest ways to actually see God's love is to go outside and experience His creation for yourself. You can see His handiwork in the flowers and trees in spring and summer. He reveals His majesty in the bright leaves showering down in the fall and in the blankets of snow He sends in the winter. Animals and creatures great and small know their Creator. The birds God created are always singing His praises as they go about their busy tasks—and you can too. God gave you your voice to talk to Him, to tell of His great love, and to sing His praises.

Thanks for showing Your love for me through Your creation, Father. I love to sing Your praises.

Day 301

Accolades

*Your Father, who sees what is done
in secret, will reward you.*
MATTHEW 6:4 NIV

The countless things we women do for our families are often not noticed or appreciated. What a comfort to know that our Father sees *everything*, no matter how small. Our reward may not be the Woman of the Year award, or even hugs and kisses. It may not be here on earth at all. I'm hoping it'll be a maid and cook for all eternity. But whatever it is, we'll be *thrilled* because our Father is pleased with us.

> *Dear Lord, thank You for the family You have given me
> to love and serve. Forgive me for the times when I have
> craved their approval more than Yours. Forgive me for
> doing my good deeds so others will notice. You see; You
> notice; You are pleased. And that is enough. Amen.*

Day 302

Wonderfully Made

Your eyes saw me before I was put together.
And all the days of my life were written in Your
book before any of them came to be.
Psalm 139:16 NLV

Check out what the Bible says about you in Psalm 139:13–14 (NIV): "For you created my inmost being; you knit me together in my mother's womb. I praise you because I am fearfully and wonderfully made; your works are wonderful, I know that full well." Imagine Jesus putting you together before you were born. He knows everything about you, and He cares for you more than anything else in creation. The next time you're feeling down or unimportant or lonely, remember who made you and how much He loves you!

Jesus, You made me wonderfully. I accept
that and rejoice in who You made me to be.
You see me, Lord. And I love You.

Day 303

The Power of Prayer

Therefore, confess your sins to one another [your false steps, your offenses], and pray for one another, that you may be healed and restored. The heartfelt and persistent prayer of a righteous man (believer) can accomplish much [when put into action and made effective by God—it is dynamic and can have tremendous power].

JAMES 5:16 AMP

Prayer is very powerful. Not only do we get to know God better when we talk to Him, but our prayers can make things happen. God's Word tells us to pray for others so that they can be healed and restored. This means that not only can physical bodies be healed, but also broken hearts can be fixed. Bring whatever is on your heart today to Jesus for healing. What friends and family members need His loving touch? Your prayers can make all the difference!

Lord, please increase my faith in the power of my prayers.

Day 304
Easy as ABC

*God has done all this, so that we will look for him and
reach out and find him. He isn't far from any of us.*
ACTS 17:27 CEV

God is near. But we must reach out for Him. There's a line
that we choose to cross, a specific action we take. We can't
ooze into the kingdom of God; it's an intentional decision. It's
simple, really—as simple as ABC. *A* is Admitting we're sinful
and in need of a Savior. *B* is Believing that Jesus died for our
sins and rose from the grave. *C* is Committing our lives to Him.
Life everlasting is then ours.

> *Dear Lord, I admit I'm a sinner. I believe that Jesus
> died for my sins and rose from the grave. I commit
> my life to Him. There's nothing complicated about
> that prayer; a child could pray it. Thank You for
> being as near as those three words. Amen.*

Day 305

Your Tears Matter

You have taken account of my wanderings; put my tears in Your bottle. Are they not recorded in Your book? Then my enemies will turn back in the day when I call; this I know, that God is for me.

<small>PSALM 56:8–9 AMP</small>

God cares about the things that you care about. The Bible says He even counts your tears and writes them down. In the Old Testament, Jesus was referred to as the "man of sorrows" because he would be rejected by people (even some of His own friends) and He would be very familiar with pain and sadness. Whatever you're going through, Jesus understands because He's been there. Have you ever felt left out or not good enough for other people? Talk to God about it. Your tears matter to Him.

Lord, thank You for Your promises. I'm so glad that You are with me and You care about my heart. Thank You for Your comfort and healing.

Day 306

In All Things

*You're blessed when you get your inside
world—your mind and heart—put right. Then
you can see God in the outside world.*
MATTHEW 5:8 MSG

The Bible talks a lot about being "blessed" and having joy. When Jesus talks about having joy, He's talking about a deep understanding that He is with us and making everything right— no matter what. That means that even if circumstances seem dire, you can still have joy. Why? Because of this promise from God right here: "And we know that in all things God works for the good of those who love him, who have been called according to his purpose" (Romans 8:28 NIV). Commit this verse to memory. It will come in handy every day of your life. God really is working all things out for your good, even when things seem all wrong.

*Jesus, help me to trust that You're
working everything out for my good.*

Day 307

A Lavish Love

I've loved you the way my Father has loved me.
Make yourselves at home in my love. If you keep my
commands, you'll remain intimately at home in my love.

JOHN 15:9 MSG

Knowing that the God of the universe knows us personally and loves us lavishly brings us great joy. The definition of *lavish* is "to give without limit." First John 3:1 (NIV) says, "See what great love the Father has lavished on us, that we should be called children of God! And that is what we are!" God loves you without limit. Nothing can change that. You don't deserve it, so you can't possibly earn it. Rest in that truth.

Father, Your lavish love is astounding. I can't begin
to understand how You can know everything about
me and still love me without limit! I don't deserve
Your love, but I'm thankful. I love You, Lord God.

Day 308

Bestseller

*The mystery is that Christ lives in you,
and he is your hope of sharing in God's glory.*
COLOSSIANS 1:27 CEV

Everybody loves a good mystery—as long as the plot twists a bit and the good guy wins in the end. The Christian life is a mystery. It's baffling that God could love us so deeply that He sent His only Son to suffer and die for us. And now the risen Christ lives in our hearts, bridging the gap between us and God forever. What an incredible page-turner!

Dear Father, we don't understand at all why You love us so much. But thank You from the bottom of our hearts. We deserve nothing, but You have given us everything, forever. We praise Your holy, loving, generous, faithful, mysterious, glorious name. Amen.

Day 309

When You're Not Feelin' It

*Meanwhile, the moment we get tired in the waiting,
God's Spirit is right alongside helping us along. If we don't
know how or what to pray, it doesn't matter. He does our
praying in and for us, making prayer out of our wordless
sighs, our aching groans. He knows us far better than
we know ourselves. . .and keeps us present before God.*
ROMANS 8:26–27 MSG

Some days you don't feel like praying. You're not alone. Jesus is very aware of the human condition because He became one of us. God knows how you feel and why. That's why He sent His Spirit to live inside us. To encourage us always. The Spirit of God will pray in us and for us when we don't know what to pray for. . .or when we just don't feel like it. If you are feeling this way today, just sit quietly somewhere and breathe. Ask the Holy Spirit to pray for you.

*Father, I thank You for sending Your Spirit to pray
for me. You knew how much I would need that.*

Day 310
Eternal Perspectives

I will bless the LORD who guides me; even at night my heart instructs me. I know the LORD is always with me. I will not be shaken, for he is right beside me. No wonder my heart is glad, and I rejoice. My body rests in safety.
PSALM 16:7–9 NLT

With an eternal perspective, you can see problems and heartache in their proper light. Weeping may last for a little while, but joy *will* come (Psalm 30:5 NLT). Therefore, you don't have to be shaken whenever trials come. Jesus is with you always. Bring any sadness or heartache to Him. Picture yourself carrying it all to Him. He wants to help carry your load. Ask Him to help you see things through His eyes.

Jesus, I bring all my thoughts and feelings into Your presence. Please give me Your perspective. Thank You for Your constant presence in my life. I rest my heart in You.

Day 311

Living Hope

*Now faith is confidence in what we hope for
and assurance about what we do not see.*
HEBREWS 11:1 NIV

This beloved scripture has long been the Christian's definition of faith. But if reworked a smidgen, it's also the meaning of hope in Christ: hope is being sure of in whom we have placed our faith and certain of what we do not see. We don't see fragrance or love or blood flowing through our bodies, but we're certain of their existence. We can't see hope, but there's no doubt when it's alive within us. Praise God for living hope!

*Dear Father, thank You for reminding us on whom our
hope rests: Jesus, who embodies, inspires, and guarantees
our hope. Hope seems invisible, intangible, and fragile,
but through Christ, it is stronger and more enduring than
anything we face. We praise the author of hope. Amen.*

Day 312

No More Darkness

*I have come as Light into the world, so that everyone
who believes and trusts in Me [as Savior—all those
who anchor their hope in Me and rely on the truth of
My message] will not continue to live in darkness.*

JOHN 12:46 AMP

Jesus came to be a light in the darkness. When He shines His
light on anything, the darkness goes away. When you allow
Jesus to light up your heart, the darkness of sin goes away
too. Doesn't it always help to be holding someone else's hand
in the dark? It's not so frightening in the dark when we know
we're not alone. Jesus is the light that's with you always too.
You are never alone. When life on this earth seems extra dark,
remember that Jesus is holding on to you.

*Jesus, I'm so relieved and thankful that I
am never alone. You are always with me.*

Day 313
No Doubt

*Then He said to Thomas, "Reach here with
your finger, and see My hands; and put out
your hand and place it in My side. Do not be
unbelieving, but [stop doubting and] believe."*
JOHN 20:27 AMP

Jesus wants to make Himself known to you. He understands
why you are the way you are, and He has great compassion
for you. He is listening, and He loves you more than you could
imagine. You are His child, and He will never abandon you.
Even the painful things that happen in life, God will miraculously
turn into good things if you trust in Him (Romans 8:28 again!).
A lot of distractions will be coming at you always, trying to get
you to doubt God's love for you. Ask the Holy Spirit to remind
you of His amazing love whenever you start to doubt.

God, help me never to doubt Your amazing love for me!

Day 314

Aim High

My aim is to raise hopes by pointing
the way to life without end.
TITUS 1:2 MSG

No woman is an island. We're more like peninsulas. Although we sometimes feel isolated, we're connected to one another by the roots of womanhood. We're all in this together, girls. As we look around, we can't help but see sisters who need a hand, a warm smile, a caring touch. And especially hope. People *need* hope, and if we know the Lord—the source of eternal hope—it's up to us to point the way through love.

Dear Lord, we are here on earth to be Your hands and
feet and to point others to the source of our eternal
hope. Open our lives and our lips to speak Your name.
Free us from fear and the isolation of self-sufficiency.
Give us the grace to help and be helped. Amen.

Day 315

The Power inside You

My children, you are a part of God's family. You have
stood against these false preachers and had power over
them. You had power over them because the One Who
lives in you is stronger than the one who is in the world.

1 JOHN 4:4 NLV

The King James Version says it this way: "Greater is he that is
in you, than he that is in the world." This is a powerful verse
that is great to remember and say out loud whenever you're
feeling afraid. Take a minute right now, and write it down on a
sticky note. Ask the Holy Spirit to help you memorize it. With
God's power alive and at work in you, you have nothing to be
afraid of. Give thanks to God that He is with you always.

Thank You for being with me all the time, Jesus.
You've given me everything I need to live for You.

Day 316

A Living Hope

*When we have learned not to give up, it shows we
have stood the test. When we have stood the test,
it gives us hope. Hope never makes us ashamed
because the love of God has come into our hearts
through the Holy Spirit Who was given to us.*
ROMANS 5:4–5 NLV

Jesus is our living hope, and because of Him we can have a
real-life relationship with God. Our hope of heaven never goes
away, but we can also have great hope and peace right now.
We don't have to wait for heaven to know Him and experience
His love, joy, power, and peace. He wants to give that to you
now—today! God always keeps His promises, and He will be
with you always. Remember, Romans 8:28 tells us that God is
always working everything out for your good, even the hard
things.

*God, thank You for keeping Your
promises and being faithful to me always.*

Day 317
The Promise

*The Holy Spirit was given to us as a promise that we
will receive everything God has for us. God's Spirit will
be with us until God finishes His work of making us
complete. God does this to show His shining-greatness.*

EPHESIANS 1:14 NLV

Sometimes it's hard for humans to keep their promises because
they don't know what might happen in the future that could
change their minds. But God always keeps His promises! God
put His Spirit in your heart as a promise that He would start
working in your heart, and He will continue to do so for the
rest of your life. Philippians 1:6 tells us that God will finish what
He started in us. You never have to worry about God giving
up on you—He never will!

*Thank You, Lord, for filling me with Your life and hope.
I trust Your promise to finish the work You've started in me.*

Day 318

Fly Me Away

But those who hope in the LORD will renew their strength.
They will soar on wings like eagles; they will run and
not grow weary, they will walk and not be faint.

ISAIAH 40:31 NIV

On those weary days when our chins drag the ground, when our feet are stuck fast in the quagmire of everyday responsibility, this verse becomes our hope and our prayer: Mount me up with wings like eagles; Father, fly me away! Let my spirit soar above the clouds on the winds of your strength. Make me strong as a marathon runner, continuing mile after mile after mile. Be my tailwind, Lord. Amen.

Dear Father, it's not really another cup of coffee
that I need. I need Your presence. Forgive me for
looking to things outside of You to help me renew my
strength. Only You will help me walk—day in and
day out, into eternity—and not grow weary. Amen.

Day 319

Closer Than You Think

The eyes of the Lord are on those who do what is
right and good. His ears are open to their cry. . . .
The Lord is near to those who have a broken heart.
And He saves those who are broken in spirit.
PSALM 34:15, 18 NLV

Jesus is closer than you think. When your heart is broken, He is with you. When your spirit feels crushed, God is close. God's Word says that He hears your prayers and His eyes are on you. He sees you. You are important to God, and He loves you more than you could ever imagine. Sometimes God will send someone to give you an extra-special dose of love at just the right time. Sometimes He will supernaturally warm your heart with love as you talk to Him. Be on the lookout for His love.

Jesus, open my eyes to see You
more and know that You are near.

Day 320

The Great Outpouring

*And in the last days it shall be, God declares, that I will
pour out my Spirit on all flesh, and your sons and your
daughters shall prophesy, and your young men shall
see visions, and your old men shall dream dreams.*
ACTS 2:17 ESV

In the Old Testament, a prophet named Joel foretold that the
Holy Spirit would be sent to us many, many years before it
actually happened. This was all part of God's big plan to save
His people. He knew we couldn't figure out life alone. He knew
we would need a helper to teach us and lead us. So He sent
His very own Spirit to live and grow inside us. How have you
seen the Spirit at work in your life over the past month?

*Holy Spirit, please come alive in me so that Your
love and power spread to everyone around me.*

Day 321

Spiritually Alive

*Spiritually alive, we have access to everything God's
Spirit is doing, and can't be judged by unspiritual critics.
Isaiah's question, "Is there anyone around who knows
God's Spirit, anyone who knows what he is doing?" has
been answered: Christ knows, and we have Christ's Spirit.*
1 CORINTHIANS 2:15–16 MSG

When we have the Spirit of Jesus alive in us, we are being transformed. God's Word is brought to life in us, and we are able to understand things that we couldn't before—we are taught right and wrong. The ancient theologian Augustine said, "Without the Spirit we can neither love God nor keep His commandments." The Holy Spirit helps us to do both!

*Jesus, I'm so thankful I don't have to do life on my own.
You are giving me the power to accomplish everything You
ask of me. Thank You for making me spiritually alive!*

Day 322

Fearfully Made

You knit me together in my mother's womb. I praise
you because I am fearfully and wonderfully made.
PSALM 139:13–14 NIV

Crow's feet, frizzy hair, saddlebags, big feet—most women dislike something about their bodies. We feel much more fearfully than wonderfully made. But God loves us just as we are. He wants us to look past the wrinkles and see laugh footprints, to use those knobby knees for praying and age-spotted hands for serving. And in the process, praise Him for limbs that move, eyes that see, and ears that hear His Word.

Dear Father, we are Your beloved children. We know
we don't (usually) walk around fuming about our own
children's flaws and inabilities; the simple fact that they are
ours makes them beautiful. You see us like that too, beloved
Father. Thank You for creating and delighting in us. Amen.

Day 323

Feeling Lonely

For whoever does the will of my Father in heaven is my brother and sister and mother.
MATTHEW 12:50 ESV

Family is important to Jesus. Psalm 68:6 (NIV) tells us that "God sets the lonely in families." He made us to be in a community with other people. We learn from each other and grow and share God's love when we live in relationships with other people. God doesn't want us to be lonely. You are a child of God, so that means you are part of God's family! If you are having a hard time finding good friends right now, ask Jesus for help! He cares about your relationships and wants you to have the family of God around you to help you in this life.

Jesus, will You help me find other believers who love You and want to follow You? Please show me what it means to be a part of Your family.

Day 324

Rejection

Then Jesus asked them, "Didn't you ever read this in the Scriptures? 'The stone that the builders rejected has now become the cornerstone. This is the LORD's doing, and it is wonderful to see.'"

MATTHEW 21:42 NLT

Jesus knows exactly what it feels like to be rejected. During His earthly ministry, many people followed Him, but in the end, the religious leaders turned people against Him and sent Him to die on a cross. Even some of His friends betrayed Him. The crowds called for Jesus to be crucified. They humiliated him. But He endured all of the mental, emotional, and physical anguish out of His deep love for us. People rejected Jesus, but God had chosen Him. Remember this the next time you feel alone or forgotten. God chose you to be His much-loved child. Jesus sees everything that is happening to you, and He understands your heart. He is with you.

Jesus, thank You for all that You endured on my behalf. Your love is astounding.

Day 325

Laugh a Rainbow

When I see the rainbow in the clouds, I will
remember the eternal covenant between God
and every living creature on earth.
GENESIS 9:16 NLT

Ever feel like a cloud is hanging over your head? Sometimes the cloud darkens to the color of bruises, and we're deluged with cold rain that seems to have no end. When you're in the midst of one of life's thunderstorms, tape this saying to your mirror: "Cry a river, laugh a rainbow." The rainbow, the symbol of hope that God gave Noah after the flood, reminds us even today that every storm will eventually pass.

Dear Lord, thank You for Your precious promises
which sustain us when deep waters threaten to
overwhelm us. Help us to hold on to them like life
preservers. We praise You for the approaching
day when Your Son—the light of the world—will
burn away every storm cloud forever. Amen.

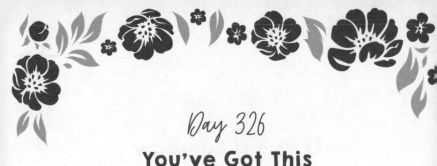

Day 326

You've Got This

*Guard the good deposit that was entrusted
to you—guard it with the help of the
Holy Spirit who lives in us.*
2 TIMOTHY 1:14 NIV

The Message says it this way: "So keep at your work, this faith and love rooted in Christ, exactly as I set it out for you. It's as sound as the day you first heard it from me. Guard this precious thing placed in your custody by the Holy Spirit who works in us." As a child of God, chosen before the foundation of the world, you've been given a special gift to guard and protect: the truth of God's saving Word. You don't have to guard this on your own, for you have the Spirit's power alive inside you. This knowledge should give you rest, not intimidation. You've got this—because He's got you!

*Lord, I'm truly beginning to see that I have nothing to
worry about. Your power is at work in me always.*

Day 327

The Helper

But the Helper (Comforter, Advocate,
Intercessor—Counselor, Strengthener, Standby),
the Holy Spirit, whom the Father will send in
My name [in My place, to represent Me and act on
My behalf], He will teach you all things. And He will
help you remember everything that I have told you.
JOHN 14:26 AMP

The Holy Spirit is our counselor, teacher, comforter, and guide—the promise that we are never alone fulfilled! The Spirit is the power of God alive inside everyone who believes and commits to following Jesus. Through His power, we have everything we need (2 Peter 1:3). When we don't know what to do, we can ask! When we don't know what to pray, the Spirit helps (Romans 8:26)!

Come, Holy Spirit. Fill my heart with Your
presence and peace. Thank You for helping
me in everything and in every way.

Day 328

Always

Teach them to do all the things I have told you. And I
am with you always, even to the end of the world.
MATTHEW 28:20 NLV

After Jesus conquered death and rose from the grave, He appeared many times to His followers. The last thing He had to say to them and to us before He went back to heaven is this: "I am with you, always." The last thing someone says to you is usually pretty important. And this is the most important thing God wanted us to know. He is Immanuel, God with us. Always. His Spirit is alive in our hearts. Any confidence we have is flimsy at best unless it is based on the knowledge that the Spirit of Christ is alive and at work within us!

Jesus, thank You for Your great love for me. Overwhelm
me with the truth that You are always with me.

Day 329

Because I Set
My Love on Him

Because he set his love on Me, therefore I will save him;
I will set him [securely] on high, because he knows My
name [he confidently trusts and relies on Me, knowing
I will never abandon him, no, never]. He will call upon
Me, and I will answer him; I will be with him in trouble;
I will rescue him and honor him. With a long life I
will satisfy him and I will let him see My salvation.
PSALM 91:14–16 AMP

As a precious daughter of the King, you are treasured in God's eyes. You can bank on His promises to you: God, your God, is striding ahead of you. He's right there with you. He won't let you down. He won't leave you. Have courage, because He will never abandon you, no, never!

I love You, God. I call on Your
name because I trust You.

Day 330

You Belong to Him

If the world hates you, you know it hated Me before it hated you. If you belonged to the world, the world would love you as its own. You do not belong to the world. I have chosen you out of the world and the world hates you.
JOHN 15:18–19 NLV

Be careful about fitting in too well with the world's culture. If you're embraced by a godless society and blend like a chameleon into its masses, it should be a warning sign to you. Jesus said that the world would reject His followers with the same animosity it showed Him. But don't be discouraged! You belong to Him. He has chosen you right out of this world and into a better one—the eternal kingdom of His Father.

Father God, it hurts when the world hates me because I love You, but this trial has a silver lining—it proves that I belong to You. Amen.

Day 331

Help for His Chosen

*The Helper (Holy Spirit) will tell about Me when He
comes. I will send Him to you from the Father. He
is the Spirit of Truth and comes from the Father.*
JOHN 15:26–27 NLV

When your courage wanes, remember the helper. You don't
have to do life all alone; you have help. The Holy Spirit moved
into your heart the moment you believed in Jesus' death and
resurrection. Don't waste this resource! The Holy Spirit can
teach, strengthen, and equip you with everything you need.
And you're His witness in this world to spread the amazing
news. Has Jesus changed you, given you hope, assisted you
in struggles, or helped you to solve problems? Tell someone.

*God, thank You for sending the Holy Spirit to help me.
Teach me to rely on You, and show me who I can tell today
about what You've done in my life. In Jesus' name, amen.*

Day 332

Chosen Daughter

The father said to his servants, "Quick! Bring the best robe and put it on him. Put a ring on his finger and sandals on his feet. Bring the fattened calf and kill it. Let's have a feast and celebrate. For this son of mine was dead and is alive again; he was lost and is found."

LUKE 15:22–24 NIV

Maybe you've collapsed on rock bottom. No matter whether we've stubbornly gone our own way or circumstances beyond our control have mercilessly cornered us, the enemy works to convince us that we must become "good enough" for God. But in truth, beloved, He has already chosen you. The returning son was shocked by His father's embrace when he'd planned to beg for a slave's position. But through Jesus, no slaves reside in His household—only heirs! Precious daughter, He celebrates you with open arms.

Father, I'm grateful and humbled that I can come home. Amen.

Day 333

Cling to Him

You shall follow the Lord your God and fear Him;
and you shall keep His commandments, listen
to His voice, serve Him, and cling to Him.
DEUTERONOMY 13:4 NASB

In a "take charge of your destiny" world, trusting God can be a hard sell. It's vital to keep our perspective in check. When we're shopping online for a new pair of boots, we read every review to discover their performance in all types of weather. And God doesn't ask us to trust Him blindly without evidence either. The Bible is loaded with positive reviews from faithful people who chose to follow His leading, even when things weren't looking so good. Allow God to lead, even in your mess, and listen for His voice. Never let go of the one who sees both ends of eternity.

Father, teach me to trust You more. In Jesus' name, amen.

Day 334
No Turning Back

We are not of those people who turn back and are lost.
Instead, we have faith to be saved from the punishment
of sin. Now faith is being sure we will get what we
hope for. It is being sure of what we cannot see.
HEBREWS 10:39–11:1 NLV

Keep your eye on the prize—it's good advice in competition and in Christianity. Our prize as followers of Christ may not be a higher-paying job, popularity, or the perfect life, but it's priceless nonetheless. Jesus chose us from the beginning of time to be the recipients of grace. He paid dearly to deliver us from a grave situation—the punishment of sin. Our faith assures us that our hope isn't misguided, that Jesus did indeed rise from the dead and deliver grace and eternal life to us.

Lord, I never want to turn back from following You.
My faith tells me my hope in You is well placed. Amen.

Day 335
Be Still

Surrender your anxiety. Be still and realize
that I am God. I am God above all the nations,
and I am exalted throughout the whole earth.

<small>PSALM 46:10 TPT</small>

Sometimes we need to be reminded that "God's got this." We wring our hands and suffer panic attacks from the uncertainty of living in this world, but all that anxious pacing is wasted energy. Our time is better spent in prayer than in panic. God gently shushes us like a mother to her upset child: "Rest easy. Just be still while I hold you. I'll take care of everything." As children we trust our parents completely to provide what we need and keep us safe, but as adults it's easier to strive than to trust. Today, rest in the knowledge that our God has big shoulders.

God, I give You my anxiety. I trust
You to work out Your plans. Amen.

Day 336

The End of Myself

Just then a woman who had been sick with a flow of blood for twelve years came from behind. She touched the bottom of His coat. She said to herself, "If I only touch the bottom of His coat, I will be healed." Then Jesus turned around. He saw her and said, "Daughter, take hope! Your faith has healed you." At once the woman was healed.

MATTHEW 9:20–22 NLV

As every option was exhausted for this woman, hopelessness probably took root. But then she heard about Jesus. And she believed He was the long-awaited Messiah, the Son of God, who had the power to change what she could not, so she reached out for the hem of His garment. And Jesus knew, as He always does. When you reach the end of yourself, reach out to Him.

Father, I know You have the power to change hard circumstances. Help me turn to You first. Amen.

Day 337

My Best Thought

*But I gave up those things that were
so important to me for Christ.*
PHILIPPIANS 3:7 NLV

*Be Thou my Vision, O Lord of my heart;
Naught be all else to me, save that Thou art—
Thou my best thought, by day or by night,
Waking or sleeping, Thy presence my light.*

I love the lilting Irish melody of this hymn, "Be Thou My Vision." Its words are sometimes attributed to Saint Dallán, a sixth-century blind monk who remained faithful and believed that God was his vision, his best thought, and his only remaining light. All the world's treasures can't compete with the friend we have in Jesus. Is He the Lord of your heart today? Is He your best thought always, the light in your darkness?

Father, keep things in perspective for me when, as Satan tempted Jesus in the desert, the things of this earth start to look appealing. I give them up for You. Amen.

Day 338

Hope for the Hard Days

If only my words were written! If only they were written down in a book! If only they were cut forever into the rock with an iron cutter and lead! But as for me, I know that the One Who bought me and made me free from sin lives, and that He will stand upon the earth in the end. Even after my skin is destroyed, yet in my flesh I will see God.

JOB 19:23–26 NLV

When you're slogging through a tough time, remember Job. We've all had bad days, but probably not like Job. God gave Satan permission to test Job, and the enemy set out to crush him. Job lost everything—possessions, children, health—but Satan couldn't touch his most precious possession: his faith in God. Job knew that no matter what atrocities happen in this life, our Redeemer lives, and one day we will see God.

Father, give me unwavering faith and hope like Job that looks ahead to the day I'll see You. Amen.

Day 339

Chosen to Be United

May they all be as one, Father, as You are in Me
and I am in You. May they belong to Us. Then
the world will believe that You sent Me.
JOHN 17:21 NLV

Getting along can be hard. Sometimes our feelings get hurt or we're busy and don't want to be bothered by the burdens of others. But Jesus' prayer for all believers was that they would belong to Him and to one another, united as one force. This unity is one of our strongest witnesses to a dark world where it's everyone for himself. They see believers come together with supernatural unity and know that something otherworldly is happening. They begin to believe that Jesus is the Son of the Most High.

Father, help me to get along with my faith family, to overlook
offenses, and to take the time to understand the problems
and setbacks others are struggling under. Amen.

Day 340
Trust Him

*Some trust in chariots and some in horses, but we trust
in the name of the LORD our God. They are brought to
their knees and fall, but we rise up and stand firm.*
PSALM 20:7–8 NIV

Do you hoard leftover pieces and parts because you might have a use for them one day? Our safety nets give us comfort. Whether it's money in the bank, food in the pantry, or life insurance, we have some peace of mind knowing it's there—just in case. Being prepared is never a bad idea, but scripture also warns us to be careful about placing our trust in things that will eventually fail. God is the backup plan who will never fail us. Only He can help us stand firm when life collapses. In what are you trusting?

*Father, sometimes I look to my own resources
and resourcefulness to save me when I should be
trusting You. Help me trust You more. Amen.*

Day 341

Make an Impression

The fear of human opinion disables;
trusting in GOD protects you from that.
PROVERBS 29:25 MSG

Have you ever been paralyzed by worry about what others think? The enemy loves peer pressure. He tricks us into using the wrong standard because we fear judgment and crave acceptance. But what if we thought as hard about what God thinks about what we're doing as we do about what friends and even perfect strangers think about how we live? When we trust that what God asks of us is always ultimately in our best interest, He protects us from fearing that others won't like us because we follow Jesus.

Father, keep my focus on the future—the bright
and glorious eternal life I have to look forward
to with You. Make my unwavering trust in You
a witness to all who see my life. Amen.

Day 342

Safe Space

*My being safe and my honor rest with God.
My safe place is in God, the rock of my strength.
Trust in Him at all times, O people. Pour out your
heart before Him. God is a safe place for us.*
PSALM 62:7–8 NLV

The world can be pretty hostile. When we wake up and turn on the news to reports of violence, widespread disease, and economic instability, the urge to dive back into bed and yank up the covers might overtake us. Getting through the day is a hard-won battle when anxiety and uncertainty assault us at every turn. But in the midst of all this trouble, we have the rock—a big, sturdy fortress we can run to for comfort. God is a safe place to be. Pour out your problems to Him today.

*God, protect me and give me
courage in this dark place. Amen.*

Day 343

Chosen to Rejoice

*I write these things to you who believe in
the name of the Son of God so that you
may know that you have eternal life.*

1 JOHN 5:13 NIV

Is your joy flagging? Are you feeling despondent about the life you've been handed? Nothing brightens a day like a gift wrapped in ribbons and bows. God's gift to you may not be wrapped in designer paper, but He is handing out the best gift you'll ever receive—eternal life when you believe in the name of His Son, Jesus. It's earth-shattering news that should rattle your world. Death is not the end but only a doorway. Your real life with God begins when You believe, and it will never end. Allow this truth to put joy in your heart today.

*Jesus, You gave everything so that I could
be with You forever. Thank You! Amen.*

Day 344
Trust

*Look at the birds in the sky. They do not plant seeds.
They do not gather grain. They do not put grain into
a building to keep. Yet your Father in heaven feeds
them! Are you not more important than the birds?*
MATTHEW 6:26 NLV

Step outside, and listen. Do you hear the cheerful chatter of the birds or see a flash of bright wing in the foliage? Birds thrive through no trouble or toil of their own. Chosen one, never doubt that you are far more precious to your Father than a tiny songbird. But giving Him our trust even in the small things means abandoning our worry and obsession over what's going to happen tomorrow, how long we'll live, or what mark we'll leave behind. Embrace trust today.

*Father, You've given me life and this beautiful
world I live in. Help me to trust that You
can do anything for me. Amen.*

Day 345
Come

Come, all you who are thirsty, come to the waters;
and you who have no money, come, buy and eat! Come,
buy wine and milk without money and without cost.
Why spend money on what is not bread, and your labor
on what does not satisfy? Listen, listen to me, and eat
what is good, and you will delight in the richest of fare.
Give ear and come to me; listen, that you may live.
ISAIAH 55:1–3 NIV

We have to do only one thing to find mercy with God—come.
Isaiah says to eat what is good, no payment required. Put down
the empty satisfaction of the world. Come. Delight in the feast
that is the gospel message of Jesus.

Father, I've tried taking in the things that this
world spreads before me. They look delicious
but offer no sustenance for my soul. Amen.

Day 346
Claimed

*For this reason, beloved ones, be eager to confirm
and validate that God has invited you to salvation
and claimed you as his own. If you do these things,
you will never stumble. As a result, the kingdom's
gates will open wide to you as God choreographs
your triumphant entrance into the eternal kingdom
of our Lord and Savior, Jesus the Messiah.*

2 PETER 1:10–11 TPT

I love the picture this verse stirs in my imagination. That God
extends a hand to you and leads you onto the dance floor of life.
He has choreographed all the moves and supports you so that
you don't stumble. All you have to do is let Him lead, and He
will dance you right into eternity with the one who saved You.

*Father, You've claimed me as Your own. I belong to You.
Strengthen me to choose love over offense every day. Amen.*

Day 347

Delightful Words

When your words came, I ate them; they
were my joy and my heart's delight, for I
bear your name, LORD God Almighty.
JEREMIAH 15:16 NIV

Jeremiah was a prophet during a time when God's people were faithless and worshipping false idols. He lived a difficult life in the midst of persecution. While we may not build altars to images carved in wood and stone today, we build a lot of other things that steal our affections from God. We amass wealth and chase after comfort and our own pleasure. But Jeremiah refused to join the revelers. Instead, he feasted on God's words and was nourished. His delight was living God's way, and joy flooded his heart even in dark times. Grab your Bible and rediscover joy in His Word today.

Heavenly Father, people around me are searching
for hope. Make Your Word my joy and happiness
so others will see the hope I have in You. Amen.

Day 348

Thirsting for More

As the deer pants for streams of water, so my soul pants for you, my God. My soul thirsts for God, for the living God. When can I go and meet with God?
PSALM 42:1–2 NIV

Water is the one thing our bodies can't survive long without. Thirst is a driving need that can leave us single-mindedly focused on one thing—finding water. Do you seek after God with a driving desire and the knowledge that you can survive only a short time without Him? Jesus offers us living water that will satisfy our parched souls, life in the face of death, peace in turmoil, rest in a chaotic world. When you drink of His love, grace, and forgiveness, you'll never look elsewhere for satisfaction.

Father, I need You. My soul thirsts for more of You. Keep me from returning to drink from empty wells. Amen.

Day 349

Trustworthy Laws

*The law of the LORD is perfect, refreshing
the soul. The statutes of the LORD are
trustworthy, making wise the simple.*
PSALM 19:7 NIV

Sheep are vulnerable to many dangers out in the pasture—wandering off, injury, and predators. Shepherds worked hard to protect their sheep and would gather them into walled sheep pens for the night, where the shepherd would sleep in the doorway. The walls contained the sheep, yes, but not because the shepherd wanted to squash their freedom—rather, because he loved his sheep and wanted them safe. God's laws sometimes feel prohibitive to our self-seeking, independent human minds. But it's vital to our spiritual survival to remember the truth—the boundaries of God's laws protect us; they give us life. The borders of His instruction are good and trustworthy.

*Lord, teach me obedience, because my rebellion against
Your instruction leads me into destruction. Amen.*

Day 350

Chosen for Glory

You are dearly loved by the Lord. He proved it by choosing you from the beginning for salvation through the Spirit, who set you apart for holiness, and through your belief in the truth. To this end he handpicked you for salvation through the gospel so that you would have the glory of our Lord Jesus Christ.

2 THESSALONIANS 2:13–14 TPT

Take a moment to consider the fantastic truth these verses contain for those who believe in Christ. From the beginning God set in motion an extraordinary plan and chose us for wonderful things—a Father's deep love, salvation through Jesus, the gift of His Holy Spirit. He set us apart for holiness, and His goal was not merely removing our burden of guilt but enabling us to share in the glory of Jesus.

Father, thank You for all that You've done for me and for choosing me from the beginning to share in Christ's glory. Amen.

Day 351
Don't Go It Alone

I am the vine; you are the branches. Whoever
abides in me and I in him, he it is that bears much
fruit, for apart from me you can do nothing.
JOHN 15:5 ESV

We all need a daily dose of Jesus. That's why He encourages believers to abide: to live for Him, trust in Him, pray continually, and be about the Father's business instead of becoming distracted by our own desires. We can't do kingdom work without Him. Sure, we can check off to-do lists and survive; we might even enjoy ourselves. But we can't accomplish anything of eternal-kingdom value without Jesus in our lives. Through the Holy Spirit, we have the mind of Christ. Think like Jesus today, and step forward into your role in God's story.

Father, without You in the center of my life,
every action I take is meaningless. Teach me
to abide and rely fully on You. Amen.

Day 352

Supernatural Support

*David said to the Philistine, "You come against me
with sword and spear and javelin, but I come against
you in the name of the Lord Almighty, the God of
the armies of Israel, whom you have defied. This
day the Lord will deliver you into my hands."*
1 SAMUEL 17:45–46 NIV

Goliath was a bully. And by outward appearances, he should
have taken David down. Life is full of bullying people and
circumstances. And fear is the biggest giant of them all. But
God loves to prove His own might and worthiness by win-
ning victories through the weakest vessels. So take courage,
straighten your spine, meet the cold eyes of fear, and step
forward to confront him—you can because God is with you.
And "greater is He who is in you than he who is in the world"
(1 John 4:4 NASB).

*Father, I can win against desperate circumstances
because the battle is Yours. Amen.*

Day 353

Chosen for Joy

I delight greatly in the LORD; my soul rejoices in my God. For he has clothed me with garments of salvation and arrayed me in a robe of his righteousness.

ISAIAH 61:10 NIV

Beloved daughter, your heavenly Father longs for a deep relationship with You. He wants your life to shine before the world as a beacon—proof that He has changed you and made your life better. Your sins are forgiven, and you will live eternally with a God who loves you immensely and delights in your presence. So let your joy overflow! When joy permeates your life, people will notice. And they may even ask what makes you different. Be ready this week to encourage the world through your joy.

Father, thank You so much for saving me! In light of this knowledge, the struggles here cannot stifle my joy. Show me who needs a smile today. Amen.

Day 354

God's Good Intentions

*You intended to harm me, but God intended
it for good to accomplish what is now being
done, the saving of many lives.*

GENESIS 50:20 NIV

The things that happen to us don't always make sense in the moment. Joseph's brothers threw him into a well, from which he was retrieved and then sold as a slave. He probably didn't understand this painful turn of his life's events, but He did choose faith and trust in a God who promises to work even the most devastating blow for good—*if* we choose to love God in spite of our pain and live right. From the ashes of jealousy God wrought forgiveness, reconciliation, and new life. He can accomplish great things through your trials too if you love Him and live faithful to His ways.

*Father, thank You that even when people want
to hurt me, I can rest in the knowledge that You
can bring about good from the bad. Amen.*

Day 355
The Rock

He is the Rock, his works are perfect,
and all his ways are just. A faithful God
who does no wrong, upright and just is he.
DEUTERONOMY 32:4 NIV

Every structure needs a foundation to hold it up, so skilled builders set their foundations on something solid. If you build on the sand, it will shift in the storms and wash out from under your foundation. The integrity of every building is only as good as its foundation. Wise people know that we'll all face hard things—our lives can be quite stormy. So they build on the rock. God is dependable and durable like solid rock. Where are you building your life? In the sands of worldly ways or on the rock?

Father, teach me to follow the good plan
I find in Your Word and build my life on
You—the rock who will never fail me. Amen.

Day 356
Hide Smart

God is good, a hiding place in tough times. He recognizes and welcomes anyone looking for help, no matter how desperate the trouble.
NAHUM 1:7 MSG

You roll out of bed, throw on some clothes, and beeline for the coffeepot. But before you even savor a single sip of your morning lifeline, trouble clotheslines you right out of the starting gate. On hostile days like this, hiding seems like a safe, maybe even wise, option. Just make sure you pick the right hiding place. God understands your frailties; He created you, after all. And He is prepared to be your hiding place. You don't even have to get back in bed and pull the covers up over your head. Instead, cover yourself with His grace, comfort, and peace.

Father, on my worst days I know I can hide out in You. You're strong enough to handle my problems and bring peace to my fearful thoughts. Amen.

Day 357

Protection of Peace

*What kind of a man is He? He speaks to the
wind and the waves and they obey Him.*
LUKE 8:25 NLV

When you feel as if your life is out of control and you are
powerless and in pain, depressed, stressed, or anxious. . .when
a situation looks hopeless, your ship sinking in the ravaging
waves of sickness, divorce, or loneliness, remember that you
know the one who calms vicious storms with the power of His
voice. The same powerful voice that said, "Let there be. . . ,"
and creation snapped into existence, can speak calm into
your soul. His peace, which is beyond comprehension in this
hostile world, will become an impenetrable wall surrounding
your heart and mind. When you realize you have no control,
remember that Jesus does.

*Lord, may others see the peace with which
You enfold me and be drawn to You. Amen.*

Day 358

He Is My Righteousness

My passion is to be consumed with him and not cling to my own "righteousness" based in keeping the written Law. My only "righteousness" will be his, based on the faithfulness of Jesus Christ—the very righteousness that comes from God.
<small>PHILIPPIANS 3:9 TPT</small>

Trying to be good enough for God will leave you discouraged and frustrated. Our failures weigh heavy on our backs. This mindset of earning God's favor can be sneaky. We have to examine our motivations carefully. Are you doing things out of love and a sense of God-directed purpose, or are you merely trying to earn your way into God's good graces? Beloved, you're already accepted. God now sees Christ's obedience as yours. And His grace is yours—free of striving for perfection.

Jesus, thank You for living the obedient life that I can't. I'm overwhelmed with gratitude that You would die to cover my mess with your pristine righteousness. Amen.

Day 359

Perfectly Content

*But godliness with contentment is great gain.
For we brought nothing into the world, and we
can take nothing out of it. But if we have food
and clothing, we will be content with that.*
1 TIMOTHY 6:6–8 NIV

We often tell ourselves that life would be grander if only we had more—more things, more time, more money, more popularity. If only we were smarter, thinner, prettier, life would be a breeze. But God has a different way of doing things, of more peace and less striving. Lay aside your grasping for more and simply be happy with the things you have. Don't know where to begin? Start small and thank God for every good thing you can see from where you're sitting.

*God, thank You for the blessing of the sun that
came up this morning. Thank You for another
day to bring glory to Your name. Amen.*

Day 360
Face-to-Face

Righteous Father, though the world does not know you,
I know you, and they know that you have sent me.
I have made you known to them, and will continue to
make you known in order that the love you have for me
may be in them and that I myself may be in them.
JOHN 17:25–26 NIV

Jesus came to show us what God is like—to introduce us face-to-face to the God who is our Father and who loves us deeply. He longs to heal our hurts and be with us. Jesus lived out God's character right in front of us. And His greatest act of kindness was the sacrifice of Jesus to pay for our sins. Now that you've met Him, are you living out His love to others?

Father, thank You for Jesus. Help me treat
everyone I encounter with Your love. Amen.

Day 361
Reality Check

I am the LORD, the Maker of all things, who stretches out the heavens, who spreads out the earth by myself.
ISAIAH 44:24 NLV

Raise your hand if you're an obsessed-with-every-detail perfectionist. If people are staring, I apologize. Maybe you're not a perfectionist at all, but you probably know one. Perfectionism is a mind plague that, if left unchecked, can convince us that we can handle God's job better than He can. That's when we need a reality check—He is God, and we are not. Details are not bad. God blesses some people with the gift of organization, but don't get caught up in thinking that God needs us to whip all the pieces in place for His plan to succeed. Take a rest from your obsession. God's got this.

Lord God, You are the all-powerful God of the universe. Increase my trust in You. Amen.

Day 362

Enduring Love

Give thanks to the God of heaven,
for his steadfast love endures forever.
PSALM 136:26 ESV

The steadfast love of God endures forever—marinate your mind in this truth for a moment. God's love for you is unfaltering, dear one. He isn't a fair-weather friend. No, His love isn't dependent on our actions. Thank goodness, because my measure would have run out long ago! His love stands forever. It's been tried and can endure anything. No matter what you've done or what has been done to you, whether you've suffered or caused suffering for others, God loves you. "God shows his love for us in that while we were still sinners, Christ died for us" (Romans 5:8 ESV). Allow God's love to permeate your mind and direct your actions.

Father, Your Word says that if I know You,
I will love others. Teach me to love as
unconditionally as You do. Amen.

Day 363

More of Him

*What good will it be for someone to gain the
whole world, yet forfeit their soul? Or what can
anyone give in exchange for their soul?*
Matthew 16:26 niv

It seems there's never enough money to satisfy our desires. If we get a raise or an unexpected bonus, we already have plans for the money and what we would do with even more—luxurious vacations, bigger homes, expensive shoes. Our desires can really run wild. But Jesus says that no matter how much stuff we can afford, or wish we could, He is the most important. Today when you talk to God in prayer, instead of asking Him for things you wish you had, ask for more of Jesus—more talks with Him, more prayer, more time in scripture.

*Father, I need more of You in my life. Give me more love,
patience, understanding, and forgiveness for others. Amen.*

Day 364

Never Abandoned

When you pass through the waters, I will be with you;
and when you pass through the rivers, they will not sweep
over you. When you walk through the fire, you will not
be burned; the flames will not set you ablaze. For I am
the LORD your God, the Holy One of Israel, your Savior.
ISAIAH 43:2–3 NIV

It's tempting to doubt God's love for us when we're suffering. The enemy whispers that if God really cared about us, He'd wipe away every trouble. But that isn't what scripture says. Jesus said that in this world we would definitely have trouble, but we need not worry, because He has overcome the world (John 16:33). Read slowly through this scripture from Isaiah and sit with the knowledge that when you experience hard times, He is with you.

Father, keep my thoughts focused on the truth of
Your presence with me even through the fire. Amen.

Day 365

Unstoppable

If God is for us, who can be against us?
ROMANS 8:31 ESV

It's been said that one sure way to get a chuckle from our heavenly Father is to tell Him our plans—because too often we cook them up without consulting Him. So it's no surprise that we sometimes fail in spectacular fashion. We fall. We lose. We crash and burn everything we've built and, in the process, maybe even those we love. But, beloved, don't kick the ashes in defeat. Sometimes the aftermath of defeat teaches us to search out God's best for us. This verse doesn't mean we'll never fail or struggle. And it certainly doesn't mean we'll accomplish every half-baked idea that turns our head. Remember that when You're following God, nothing can stand in the way of His plans.

Father, show me the plans You have for me,
plans of hope and a future. Amen.

Scripture Index

More Inspiration for Your Lovely Heart

Worry Less, Pray More

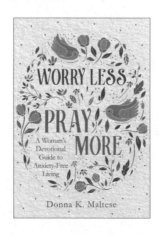

This purposeful devotional guide features 180 readings and prayers designed to help alleviate your worries as you learn to live in the peace of the Almighty God, who offers calm for your anxiety-filled soul. *Worry Less, Pray More* reinforces the truth that, with God, you can live anxiety-free every single day—whether you worry about your work, relationships, bills, the turmoil of the world, or something more.

Paperback/978-1-68322-861-5